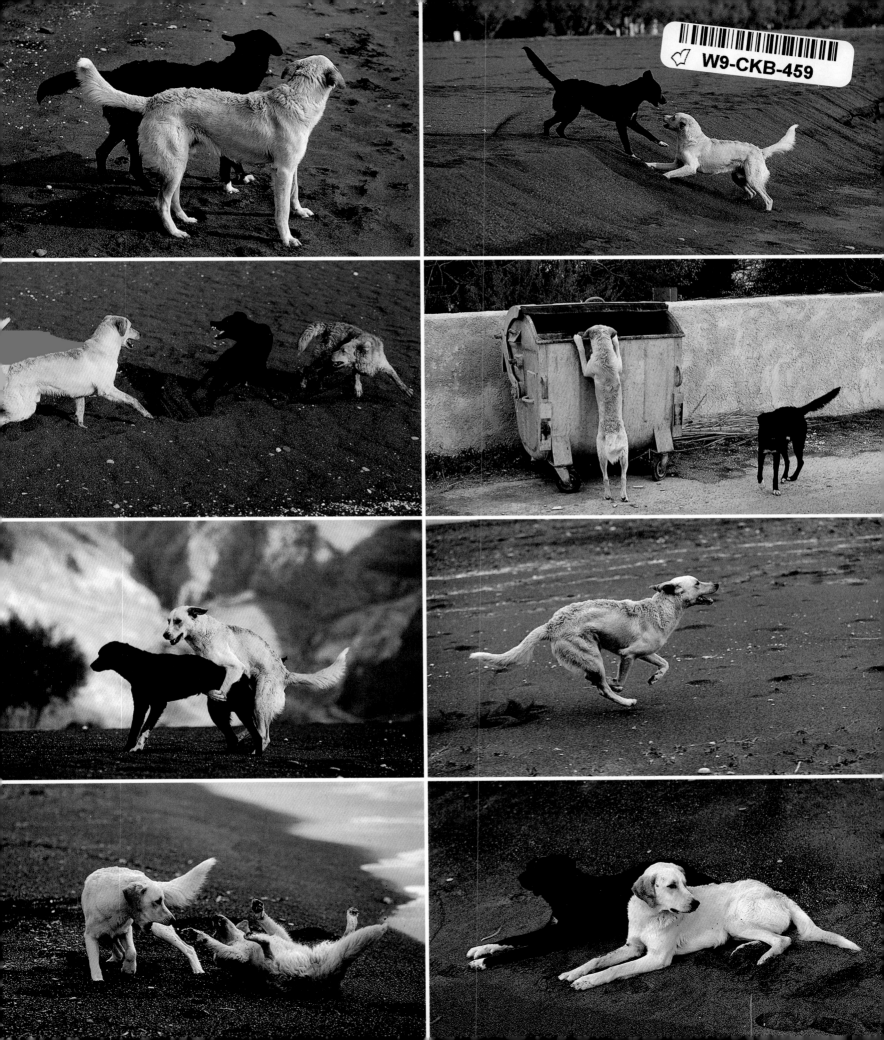

DOGS in the SUN

Hans Silvester

CHRONICLE BOOKS

SAN FRANCISCO

First published in the United States in 1998 by Chronicle Books.
Copyright © 1998 by Éditions de la Martinière.
Translation copyright © 1998 by Chronicle Books. All rights reserved.
No part of this book may be reproduced in any form without written permission from the publisher.

Library of Congress Cataloging-in-Publication Data available.
ISBN 0-8118-2237-0

Printed in France.

Jacket design : Lydia Ricci, Andrew Steinbrecher
Cover photographs : Hans Silvester

Distributed in Canada by
Raincoast Books
8680 Cambie Street
Vancouver, B.C. V6P 6M9

10 9 8 7 6 5 4 3 2 1

Chronicle Books
85 Second Street
San Francisco, California 94105

www.chroniclebooks.com

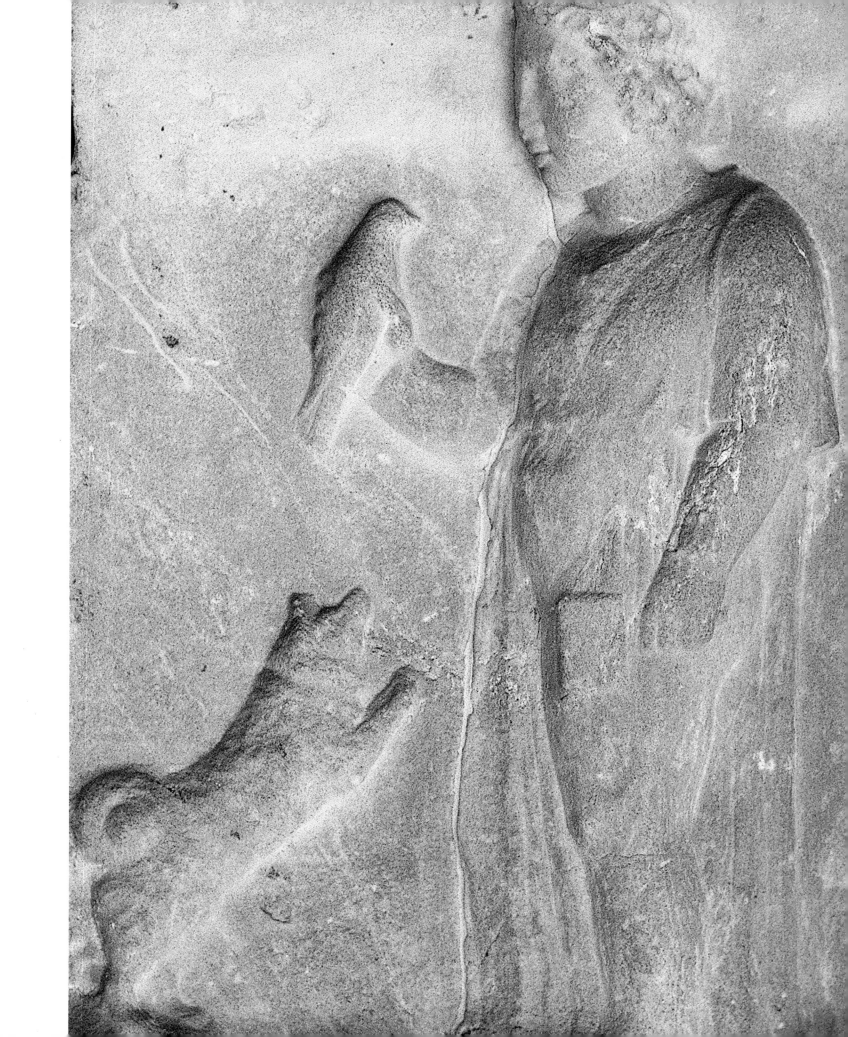

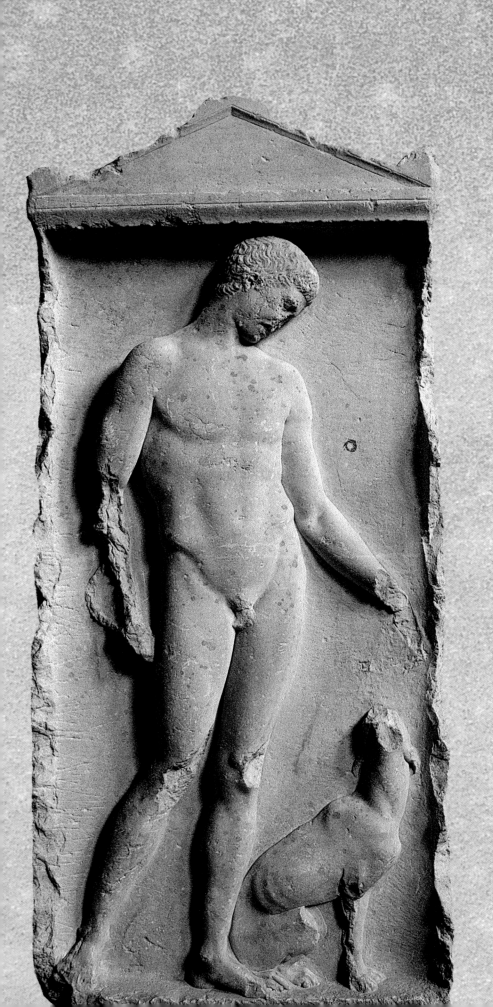

WHERE DOGS RUN FREE

Some accidents are more than just accidents; they're the beginning of fascinating stories. Take my first encounter with the dogs of Greece, a long time ago. I was on my way to photograph Gypsies, but as I got within about thirty yards of the first tent of a large encampment, I was surrounded by a pack of dogs barking fiercely, their hair raised and teeth bared. I tried to protect myself with my bag and by kicking, but the dogs only became more menacing. Suddenly—everything happened very quickly—they tore my pant leg, and bit my calf.

I was terrified in the face of this savage pack. Surrounded, I began to retreat. Instantly, the dogs understood that they had won, and became a little calmer. There were about a dozen of them, of different sizes and types. Some resembled German shepherds; others, large hunting dogs. Two or three looked like longhaired greyhounds. Back at my car, I took stock of the damage: several bites on my calf and a ripped muscle. I was bleeding profusely and in terrible pain.

This experience taught me about an ancient system of protection that the Gypsies have always used against strangers, especially men in uniform. Now I know to behave differently around such dogs. I should have shouted, and perhaps made a threatening gesture, as if to throw rocks at them, but instead I was defensive, then fearful. Worst of all, I continued moving ahead instead of stopping. I didn't stand my ground. My fear and lack of fortitude prompted the dogs to attack me.

Several years later I was back in Greece, this time to photograph cats in the Cyclades. There the cats and dogs live together, running about at liberty. These animals without masters share food, begging for leftovers at the taverns. While I was photographing the cats, the dogs became a nuisance, frightening my subjects. Therefore I avoided them and was happy when they left me in peace, but I kept an eye on them. I even became friendly with some, which, as I returned over the years, would immediately recognize and welcome me.

While they are highly visible, stray dogs represent a small minority in the Greek Islands. Most are domestic dogs living in homes, as almost every family has a dog, most often a mutt, frequently a hunting dog. This cohabitation has gone on for more than 2,500 years. In Athens's National Museum of Archaeology, numerous motifs of dogs carved in marble bear a striking resemblance to the dogs seen today.

These dogs bear little resemblance to one another, so it is impossible to speak of specific breeds. One perceives among them the characteristics of many breeds, with a great variety in size, color, and type of hair. Each dog is a true individual. (In speaking of dogs, one often uses the term "character," but I find that "individual" is more appropriate, since each dog has its own personality.)

The majority of free dogs are the offspring of stray—often nearly wild—dogs. Others were purposely abandoned on the islands, while still others are domestic dogs that join in the adventures of their footloose friends for varying lengths of time. They gather into groups and temporarily form true packs, with a head male as well as a dominant female. A dog's bearing changes radically when it is in such a group. Each animal must adapt to its role within the pack, and the pack always takes priority. Together, the

dogs are stronger and, above all, more courageous. They may even become dangerous. People of a fearful nature may feel threatened by these packs, but in reality the risk is minimal. On the other hand, strange cats and dogs have cause to worry. A dog that as an individual gets along marvelously with cats, in the pack becomes a formidable hunter of felines when the others spur him on with their aggressive behavior. This behavior is that of the wolf, with which even today dogs can and do mate.

Most inhabitants of the islands don't particularly like the packs but can tolerate them as long as their numbers don't exceed certain limits. Some people even take pity and feed the animals, mostly in winter. Hunger is the one thing these dogs have in common. They know which doors to approach and where to find the most enticing scraps and, as a last resort, the garbage. Sometimes people put collars on them so the local authorities won't mark them as strays. Thus these dogs, which seem to belong to no one, in fact belong to everyone.

The majority of the vagabond dogs would be eager to share their lives with a master. After all, they only want one thing, to be taken in. A dog's ultimate happiness derives from human love and attention. If a dog is timid, more often than not it is due to a memory of unhappy experiences with man. But reality is not always so simple. These animals lead double lives—a solitary dog that seems sad and dispirited becomes happy and full of vitality with the pack. Those that have known life in the group stay very attached to it. Even those that find a home and a good master are ready to run away the instant the pack passes by. This situation is contradictory: they want both a home and affection *and* to run free with the pack.

I wanted to observe these groups of dogs up close, but they are extremely difficult to photograph. First, I had to be accepted by the "assembly" of dogs, then I had to hang around them long enough that they would forget my presence. I also had to adapt to their mobility, as they could disappear in an instant. The extent of their territory is so considerable that on certain days they were impossible to find at all. Nobody controls the pack; the dogs always do exactly as they please. They know their island, and go without hesitation from one village to another, easily covering distances of six to nine miles. These journeys are always a sort of celebration for them. They leave the roads, chasing cats, partridges, and rabbits, and making huge detours to search for water.

The stray dogs, especially the puppies, never fail to evoke the pity of tourists. To them, these are poor, abandoned dogs. Where they come from, society believes every dog must have an owner. A dog

doesn't have the right to exist unless it belongs to someone; if not, it is a fugitive, forbidden from loitering and a candidate for the animal shelter. Some countries place a tax on dogs, something that is unimaginable in the Greek Islands. I would be suspect of any society that no longer has a place for stray dogs, and fearful of the lack of tolerance that could just as well apply to people as to animals.

Thirty-five years ago, when I first arrived in Provence, loose dogs wandered around the villages just as in Greece. But times have changed, and so has the degree of tolerance. Free dogs have become a rare breed. The wolf, the first domesticated animal, abandoned its liberty in order to live with humans. Then, when humans went from gathering to hunting, the tame wolf was transformed into the dog. Over time, the rapport between man and dog has become tighter. Today we believe that the connection goes back some forty thousand years. It was the beginning of a shared life, of a success without equivalent. First the tame wolf and then the dog became an invaluable helper in the hunt. Later the first flocks and herds were gathered, thanks to the dogs that helped herders. Dogs also protected habitations against wild beasts and thieves. Little by little, the selection of dogs suited to one task or another led to the development of many breeds of dog.

In Greece, the attitude toward animals is not the same as in other countries. Displays of affection are limited to brief moments, a rapid caress, for example, with no great show of affection. The animal is less of a slave to the human, and the human is less of a slave to the animal. Because they are more tolerant, the Greeks permit the dog to have a freer, more independent life. In Greece, dogs can be happy amongst themselves, without man's presence. This relationship with other dogs is a deep necessity, indispensable to the dog's well-being, that goes back to the time of the wolf and the pack.

It should be understood that these bands of dogs make their presence strongly felt; one can't simply ignore them. I have often observed the different reactions of tourists. Some say, "Poor beasts! How is this possible?" Others, "They're amusing, these dogs." Still others caress and talk to them, or want to take photos next to them. Some exclaim, "They're hungry!" and immediately buy them something to eat. But the Greeks? They are so accustomed to seeing them that they don't pay them any attention.

The Greeks are frequently amazed by the behavior of tourists in their country. They watch with astonishment as tourists fall in love with stray dogs, and are even more surprised when they see the same tourists at the airport with a dog in a traveling cage, ready to fly it home. This makes them laugh, and they say to themselves, "So much effort for some mutt!"

It is difficult for them to imagine this dog in a big house or an apartment, difficult to imagine that it is going to have a happy life, that it will be loved and pampered. It will probably not miss much, but I'm sure that somewhere deep inside it will sense another kind of life, less solitary, where there is adventure every day, where a dog can run wild and find a place in the pack, a life where humans are less present, where a dog can be a dog, and nothing but a dog.

Hans Silvester

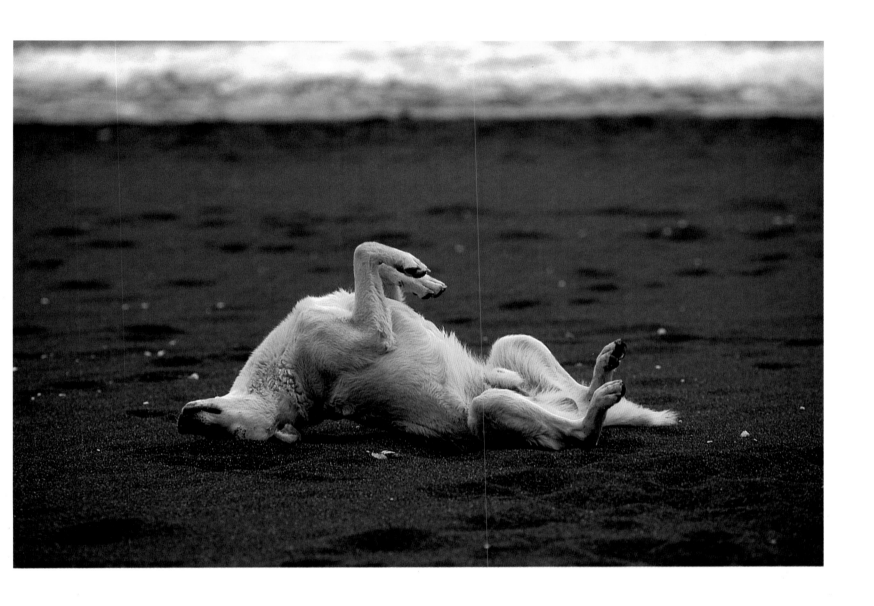

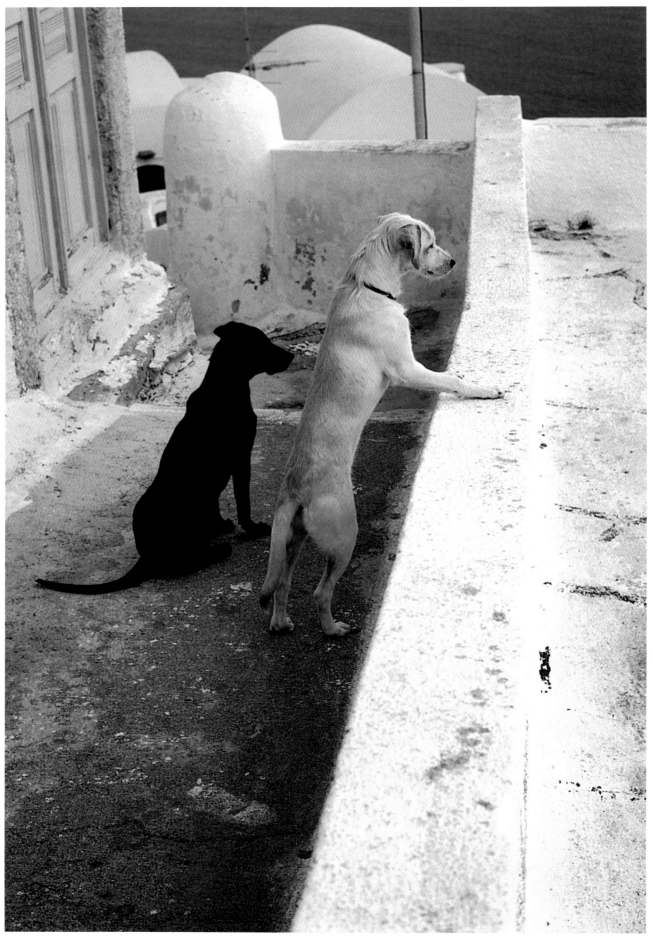

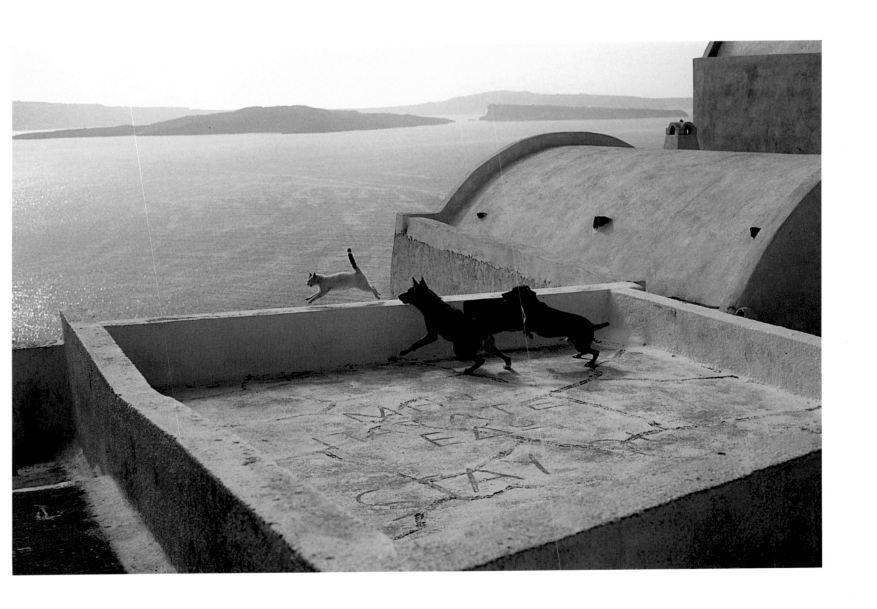

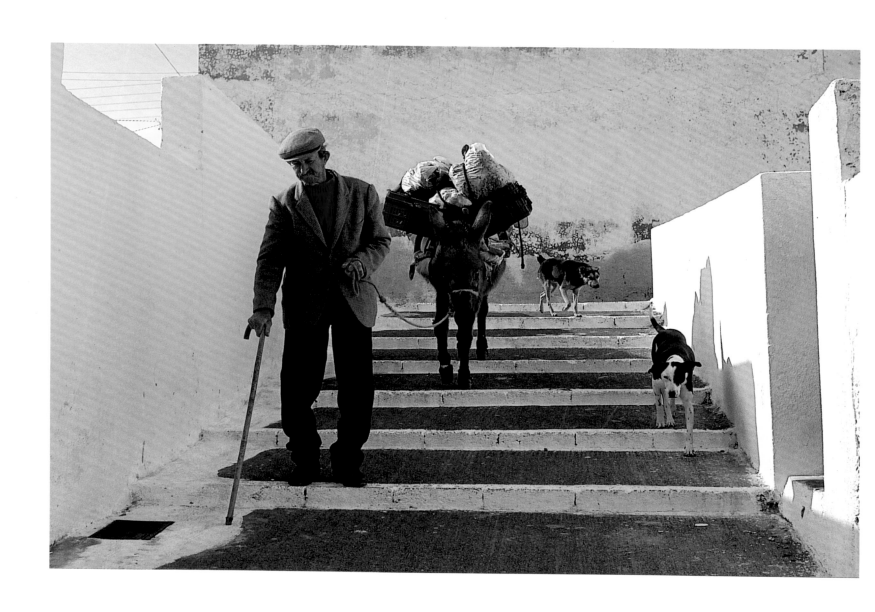

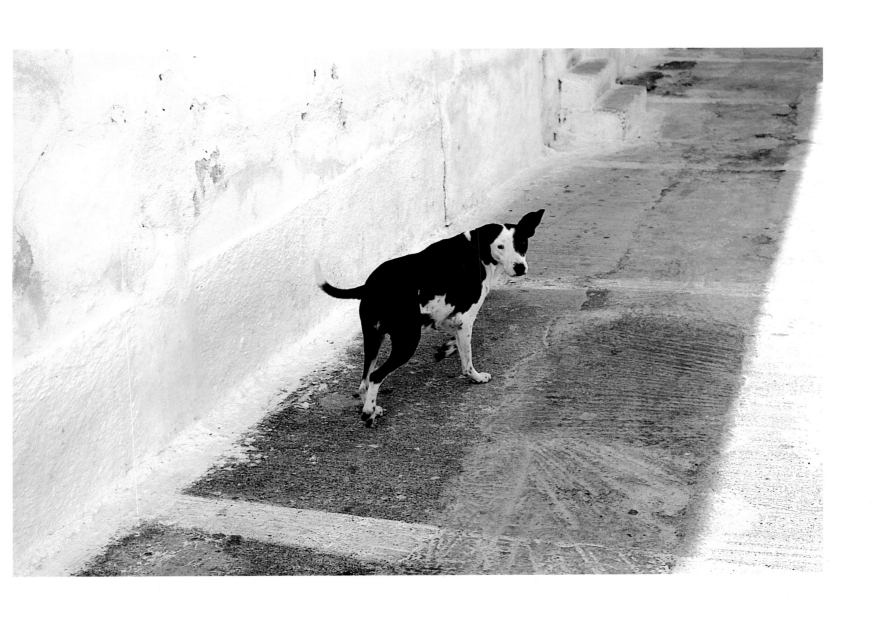

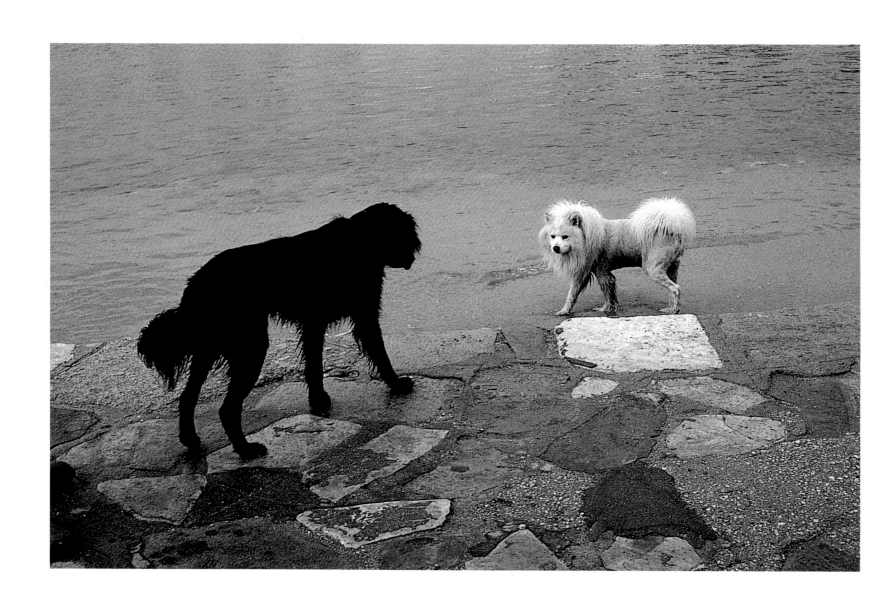

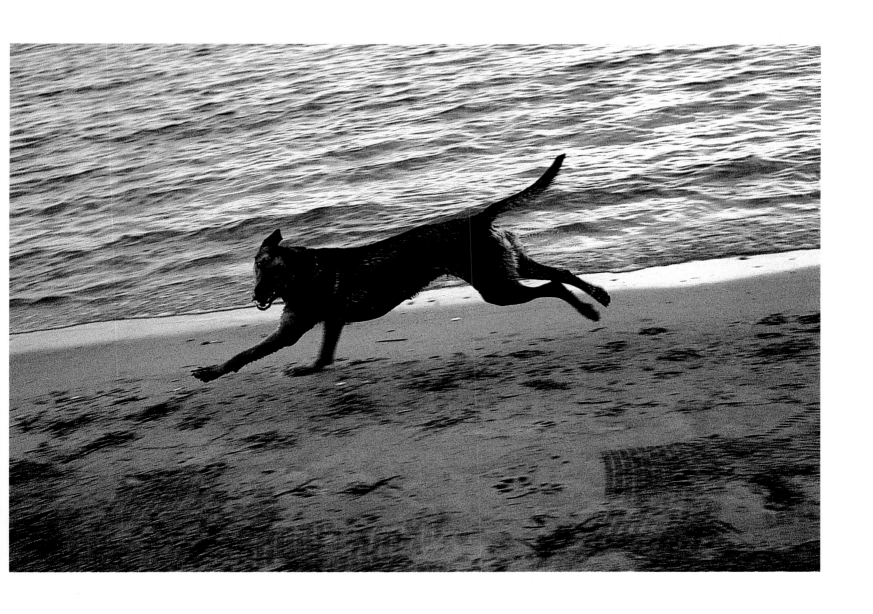

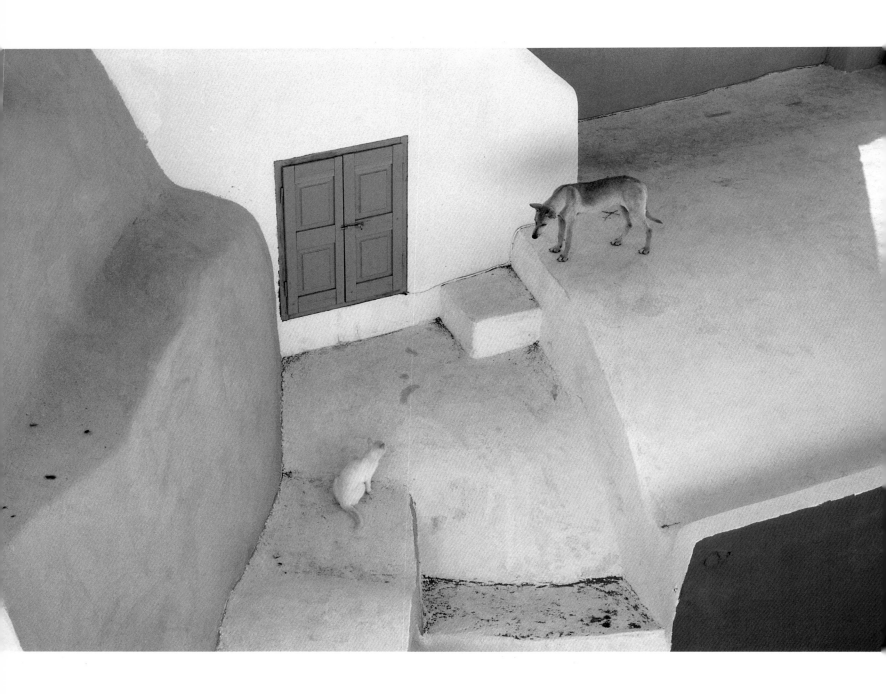

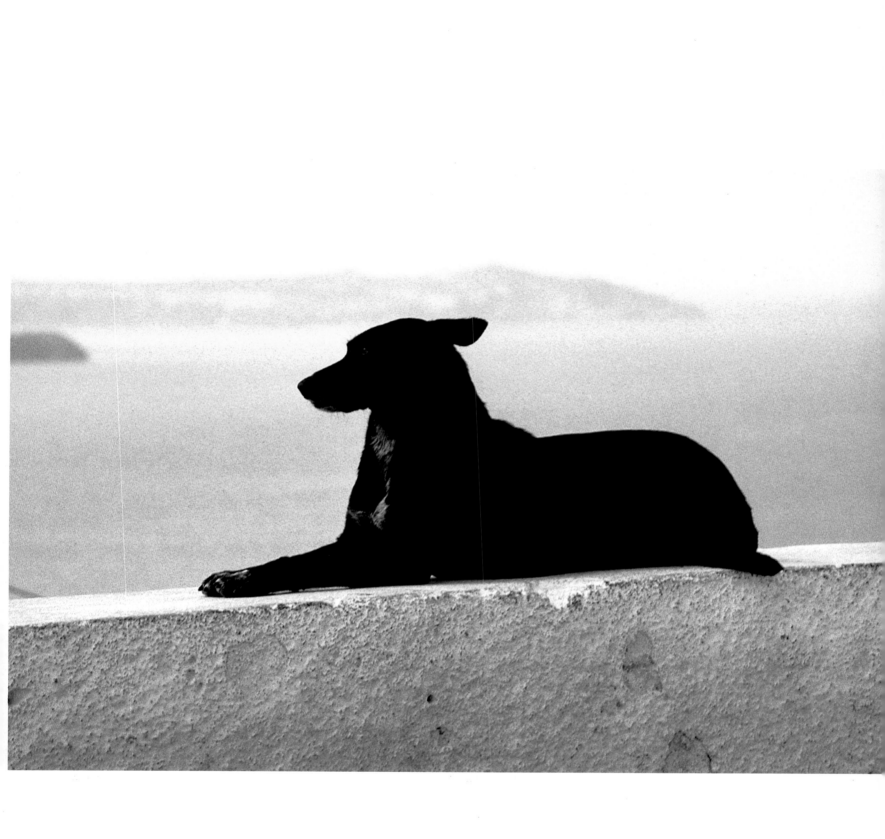

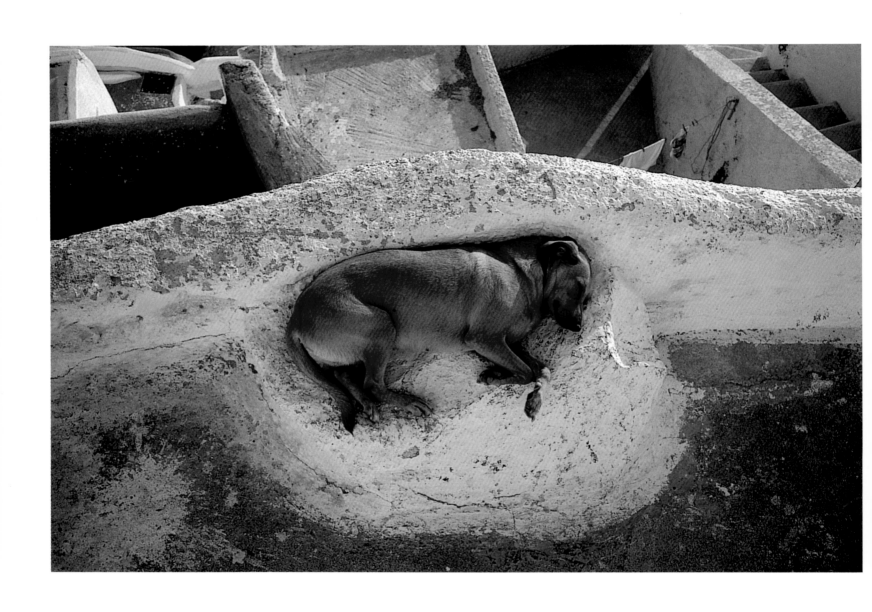

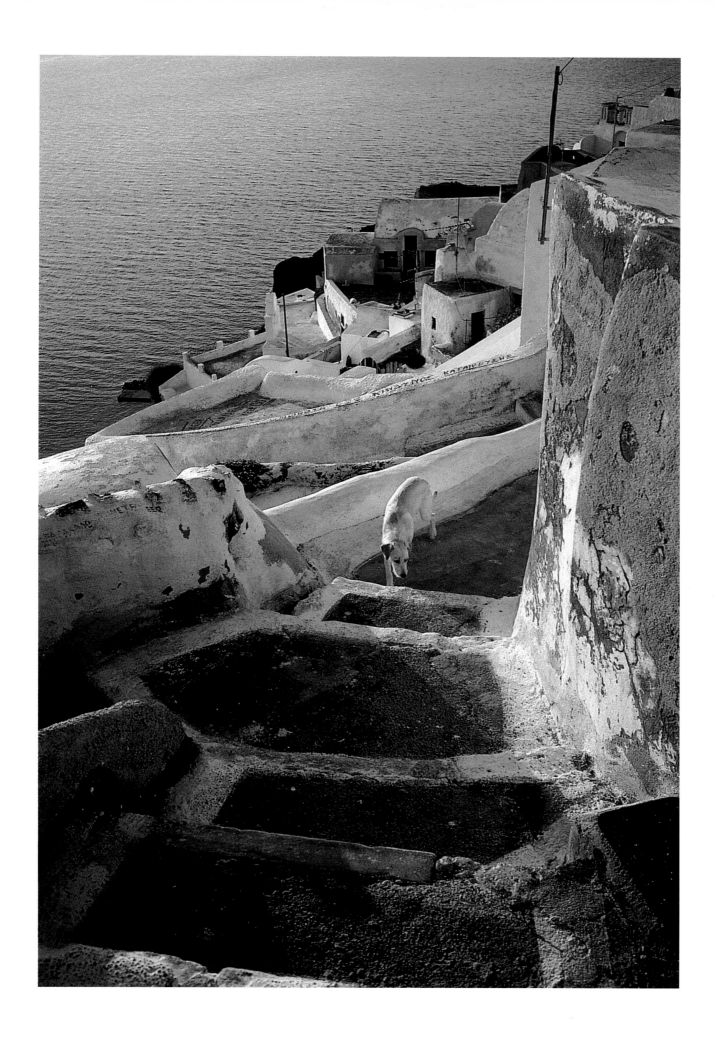

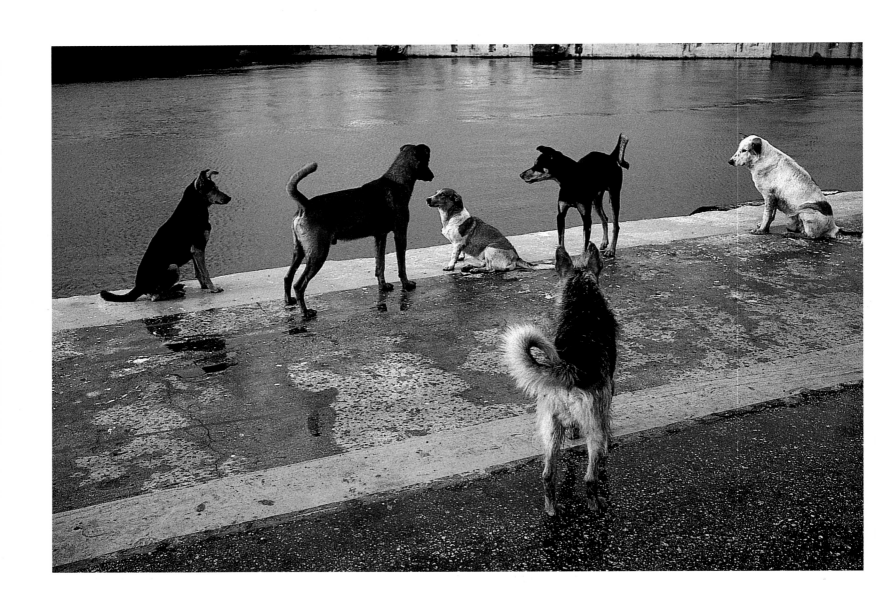

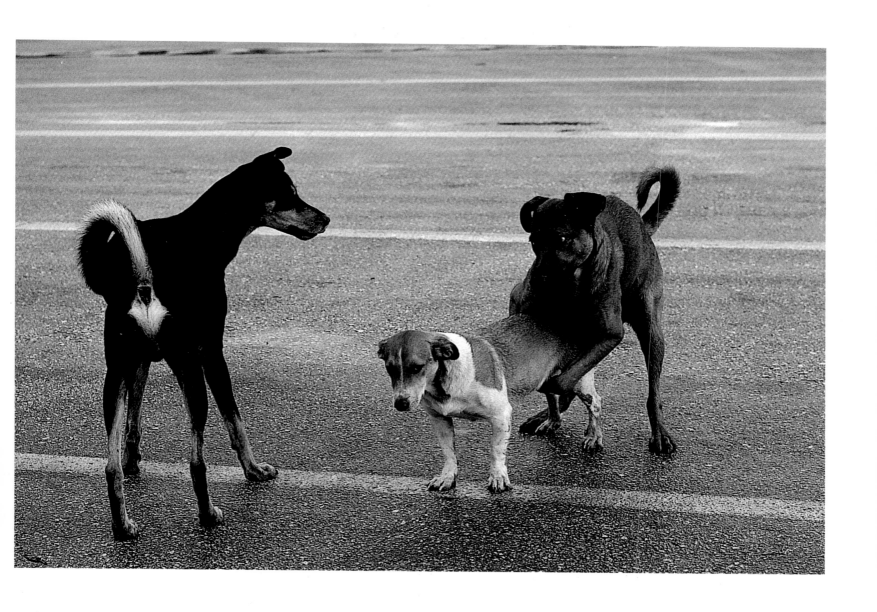

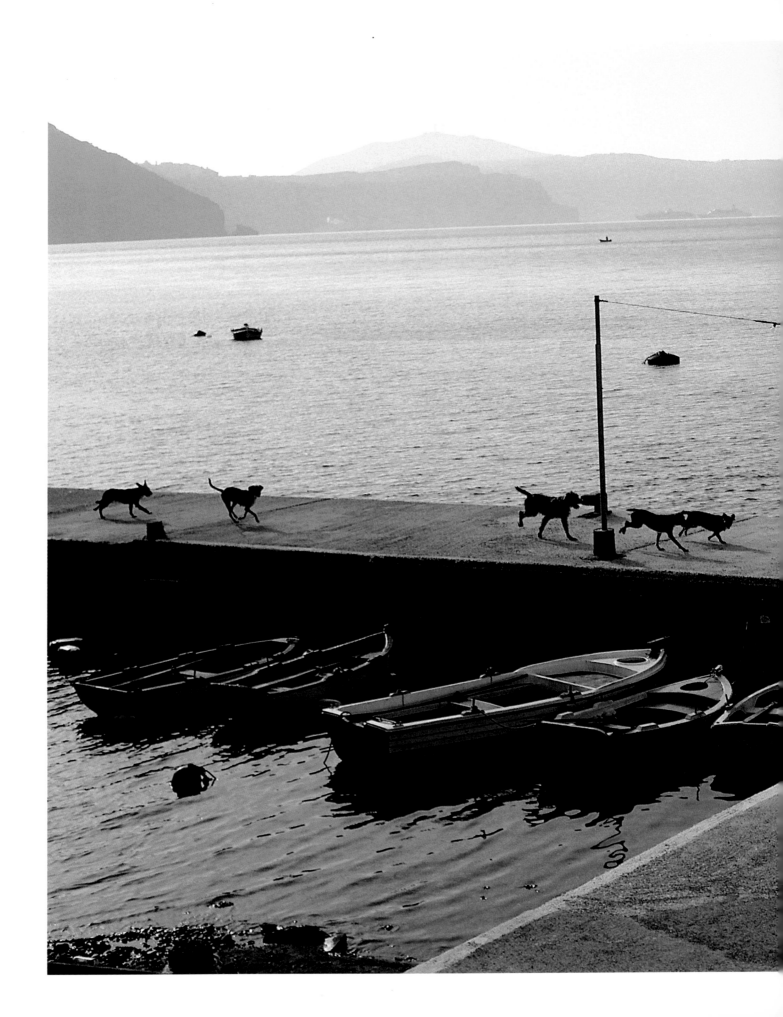

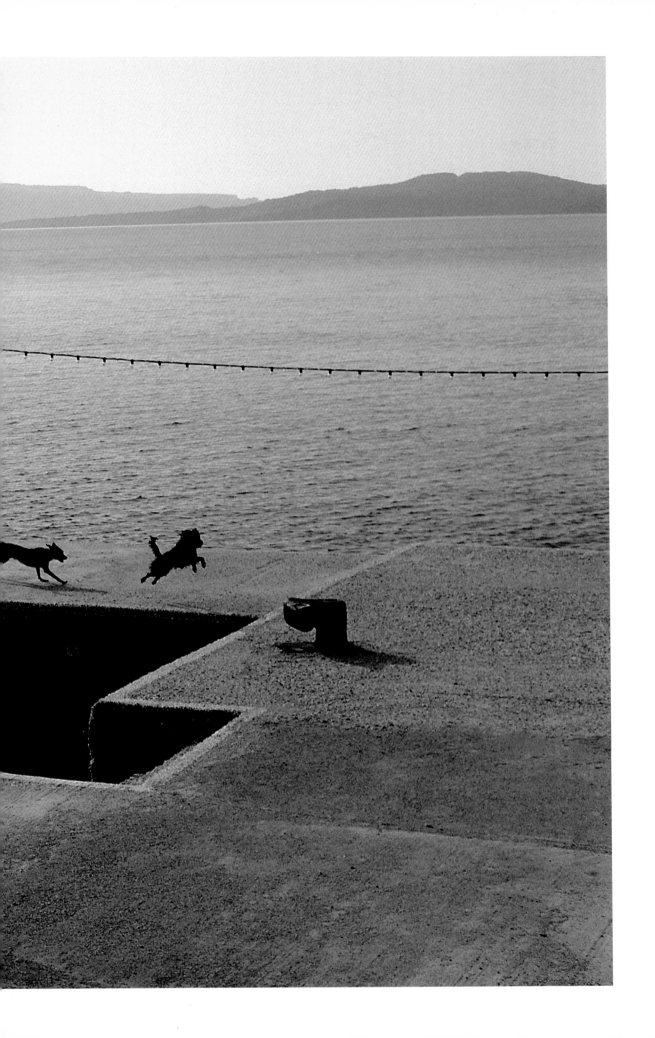

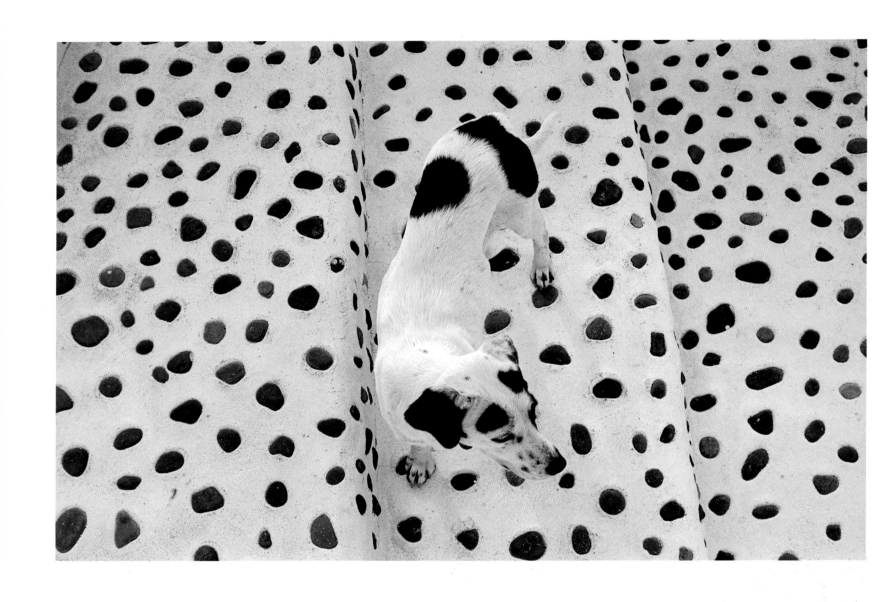

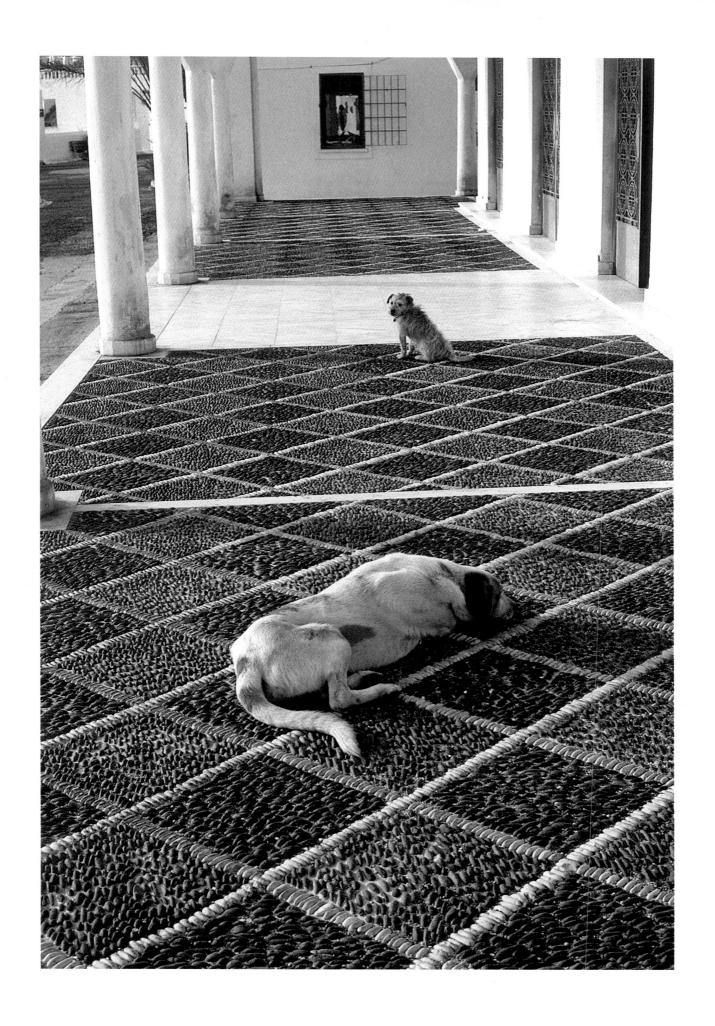

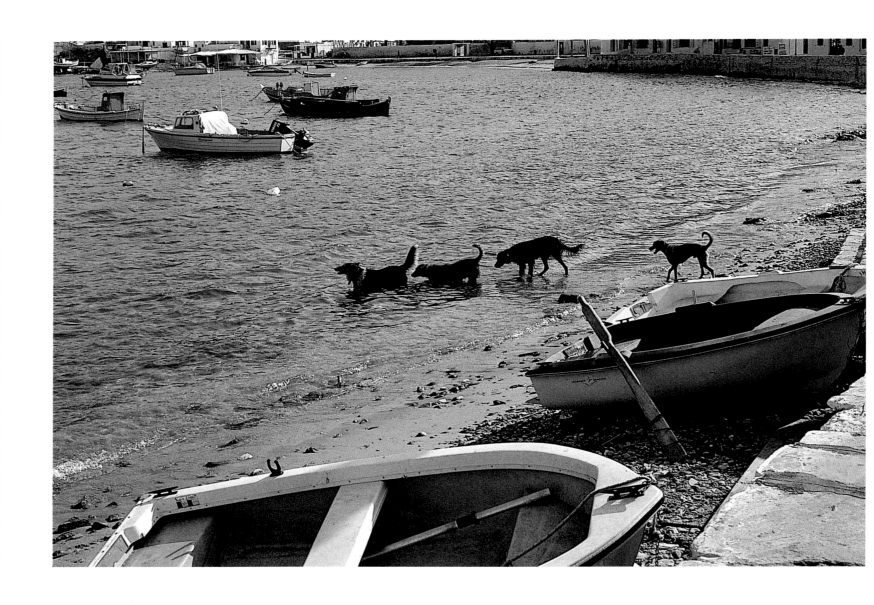

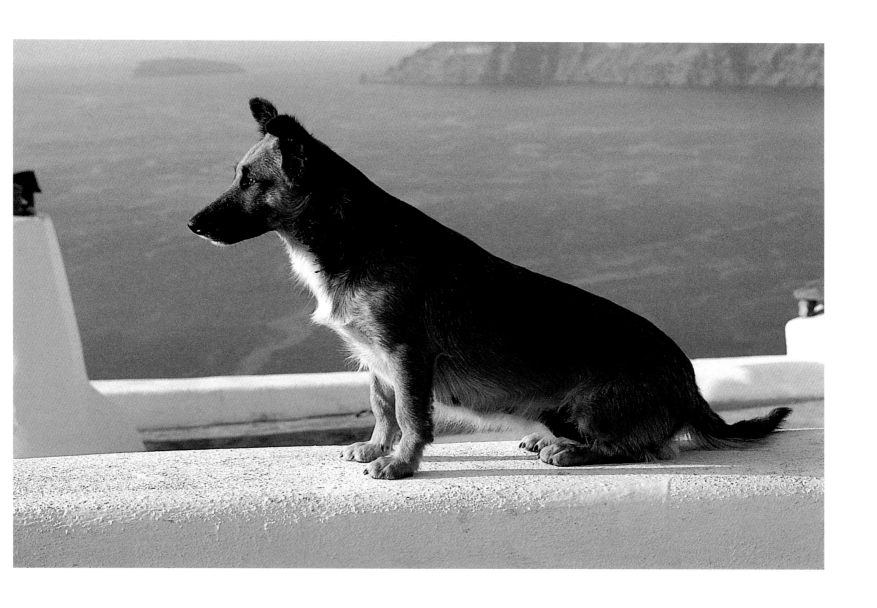

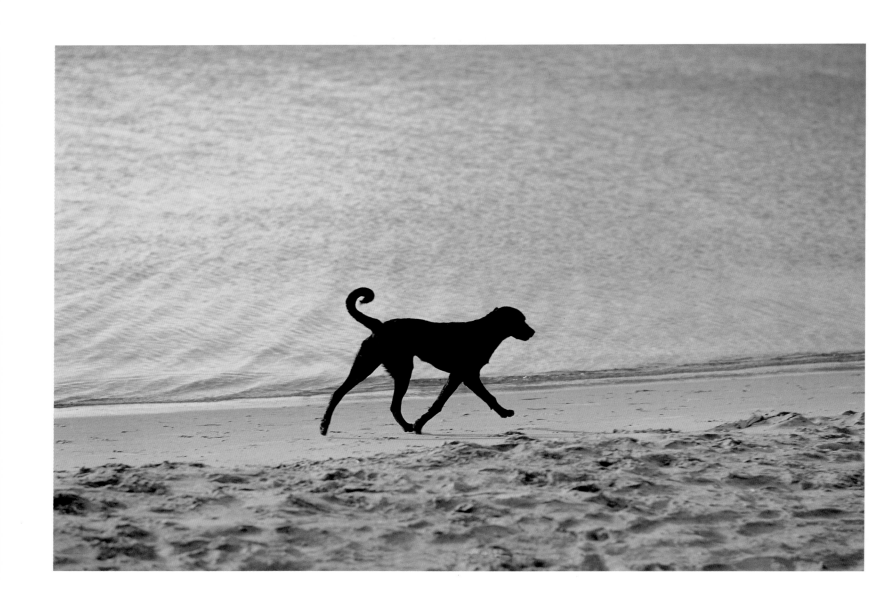

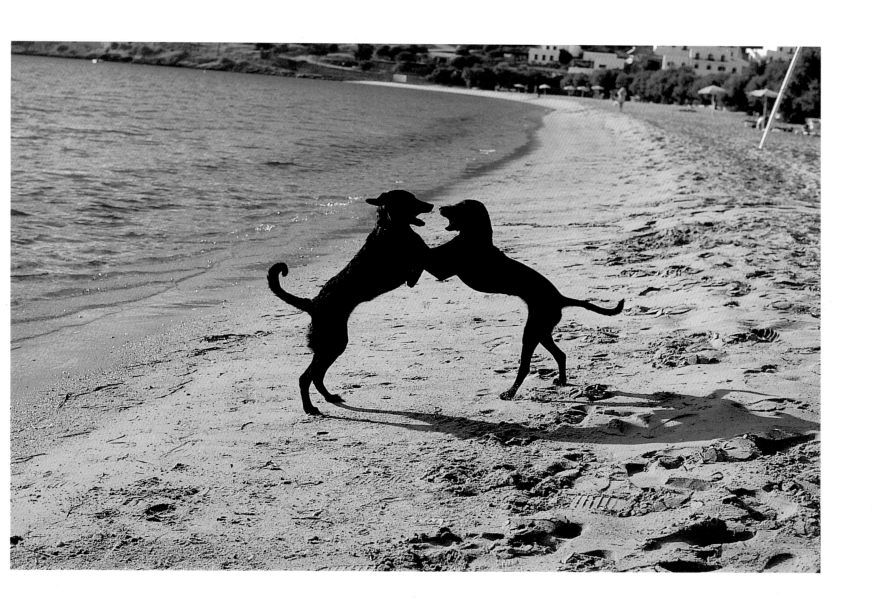

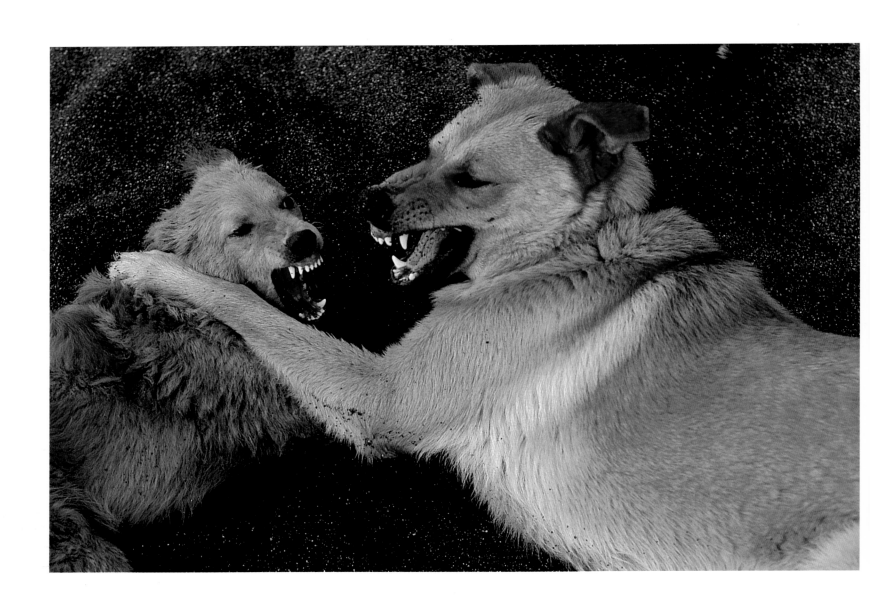

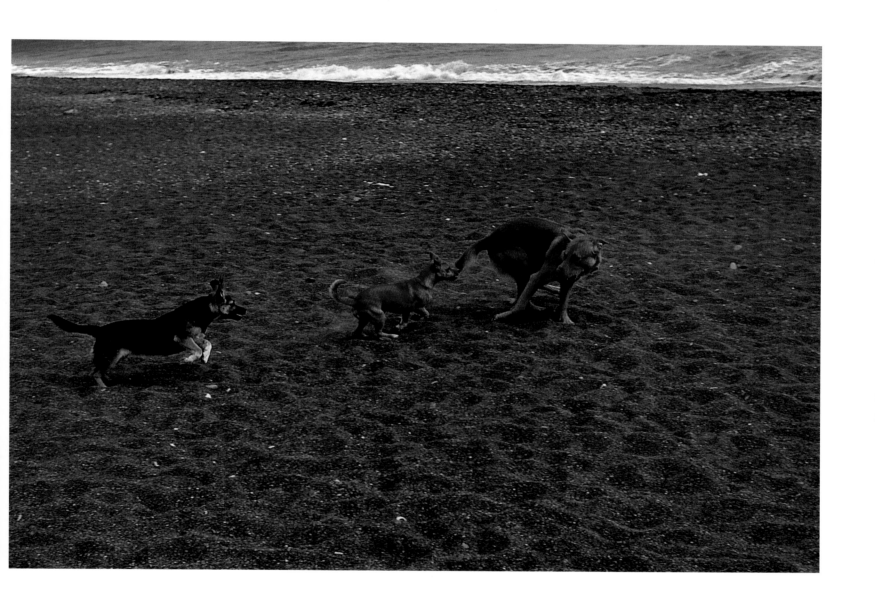

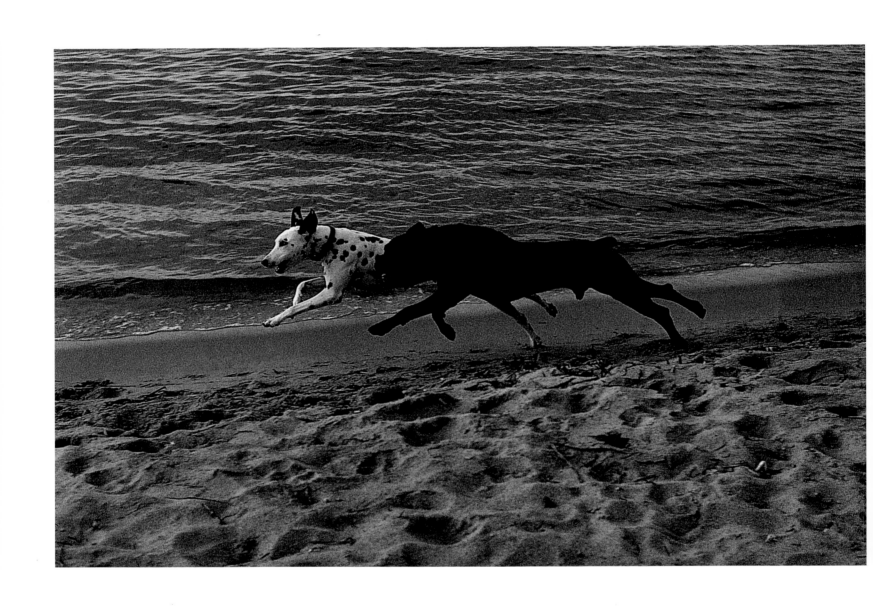

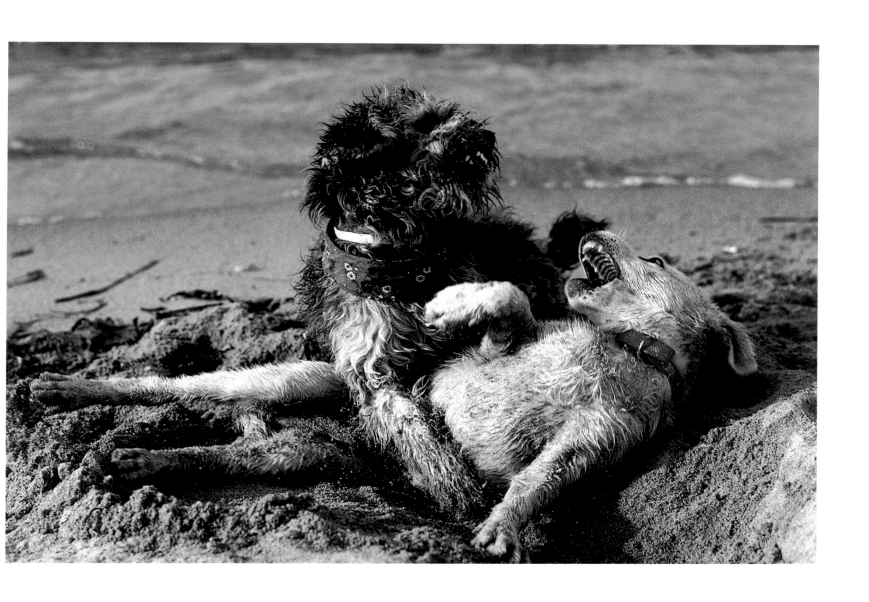

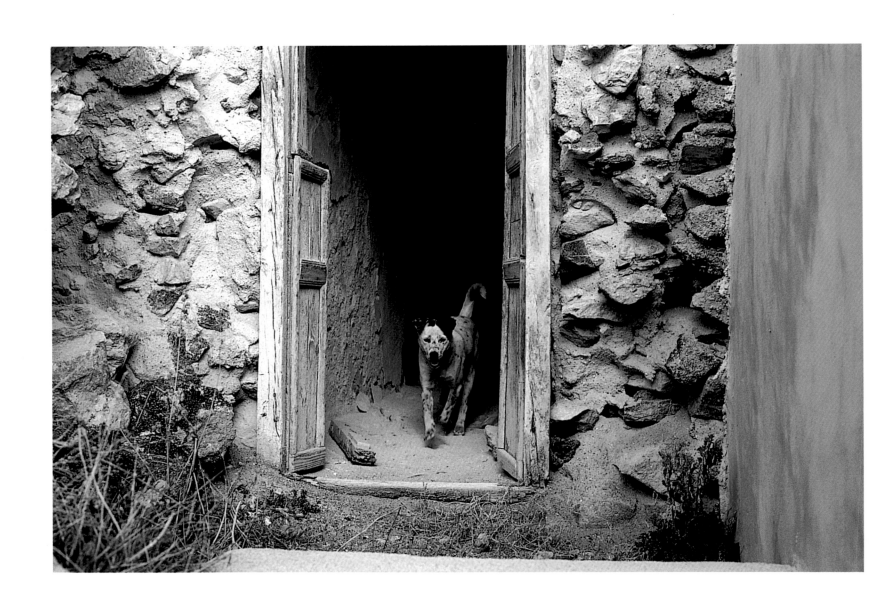

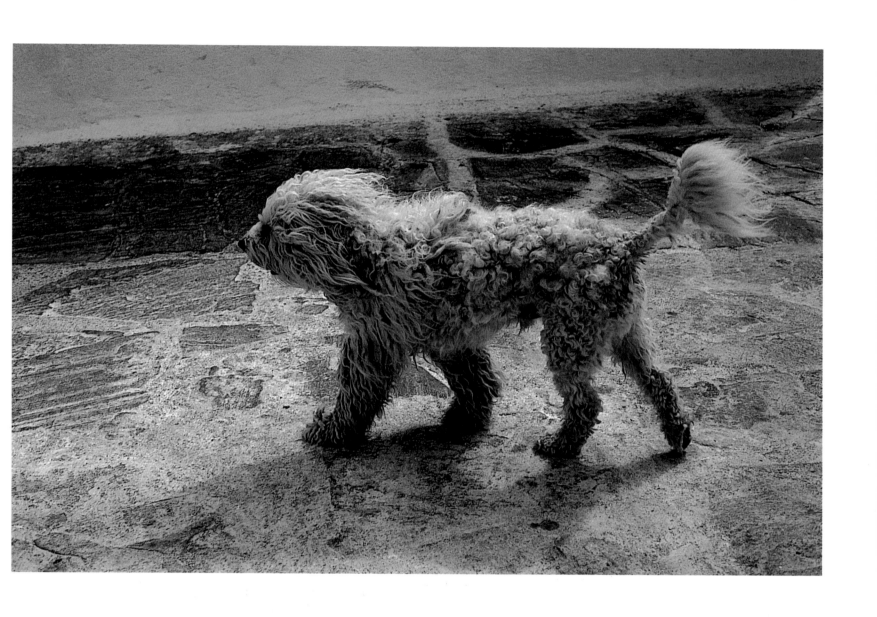

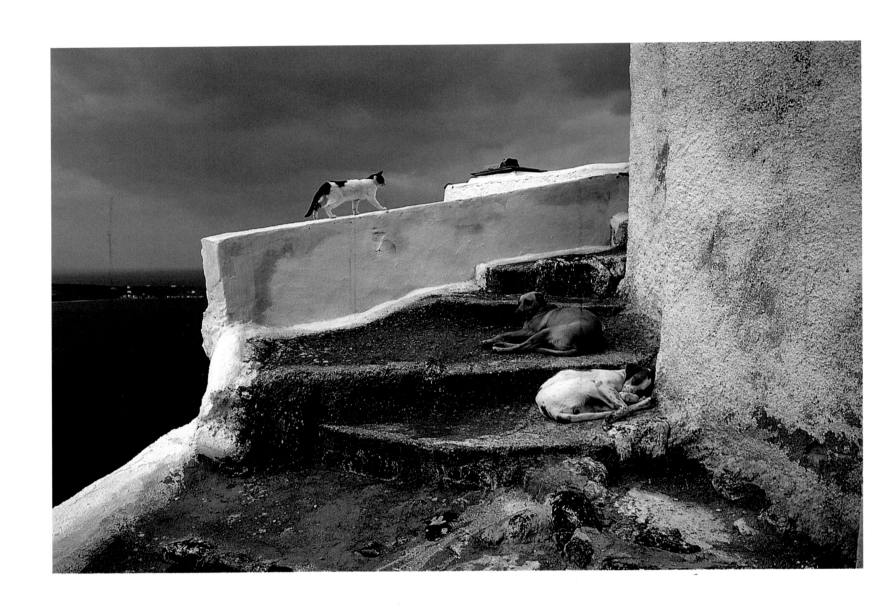

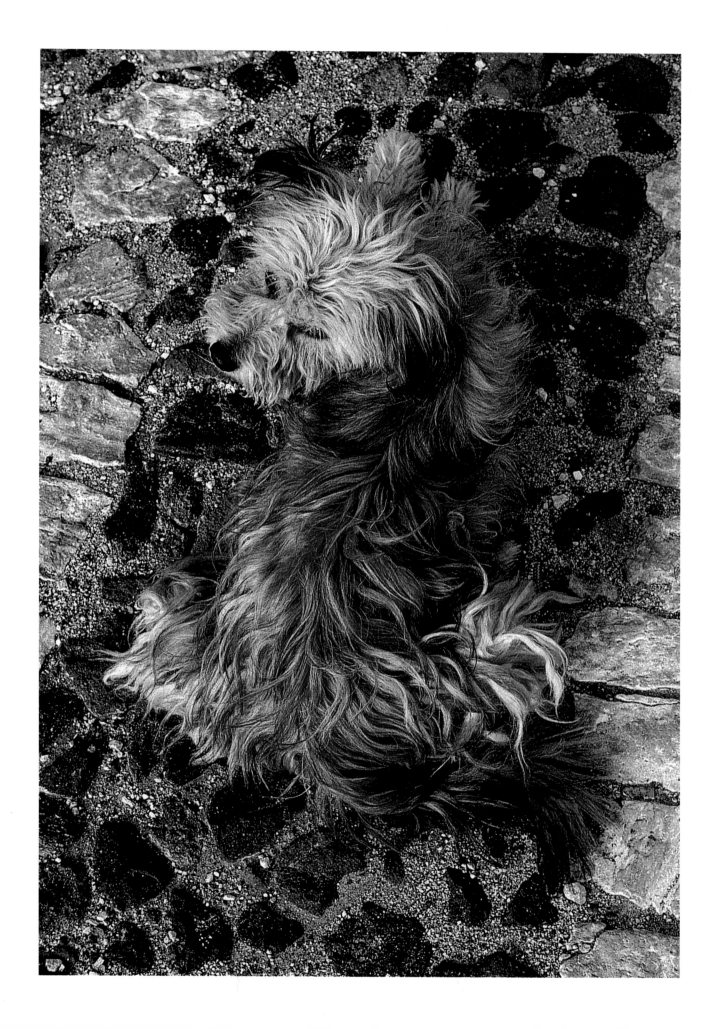

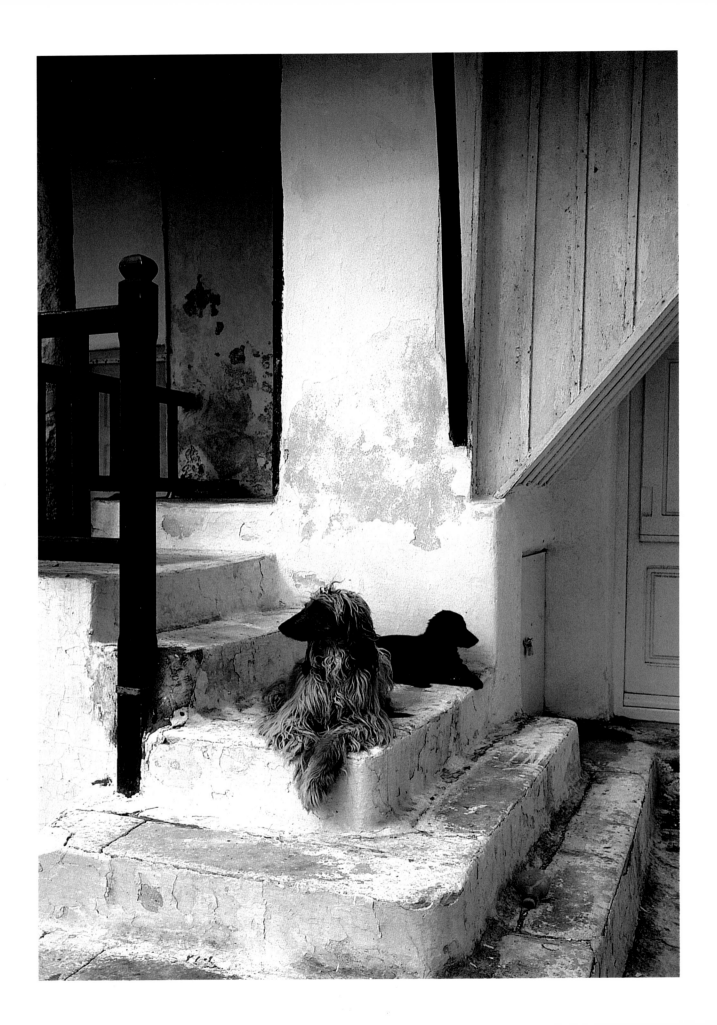

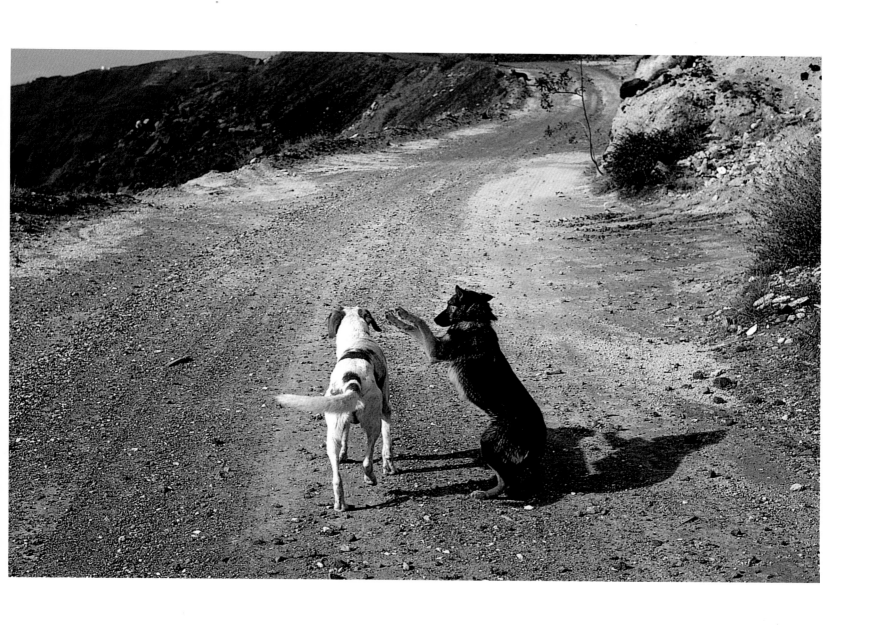

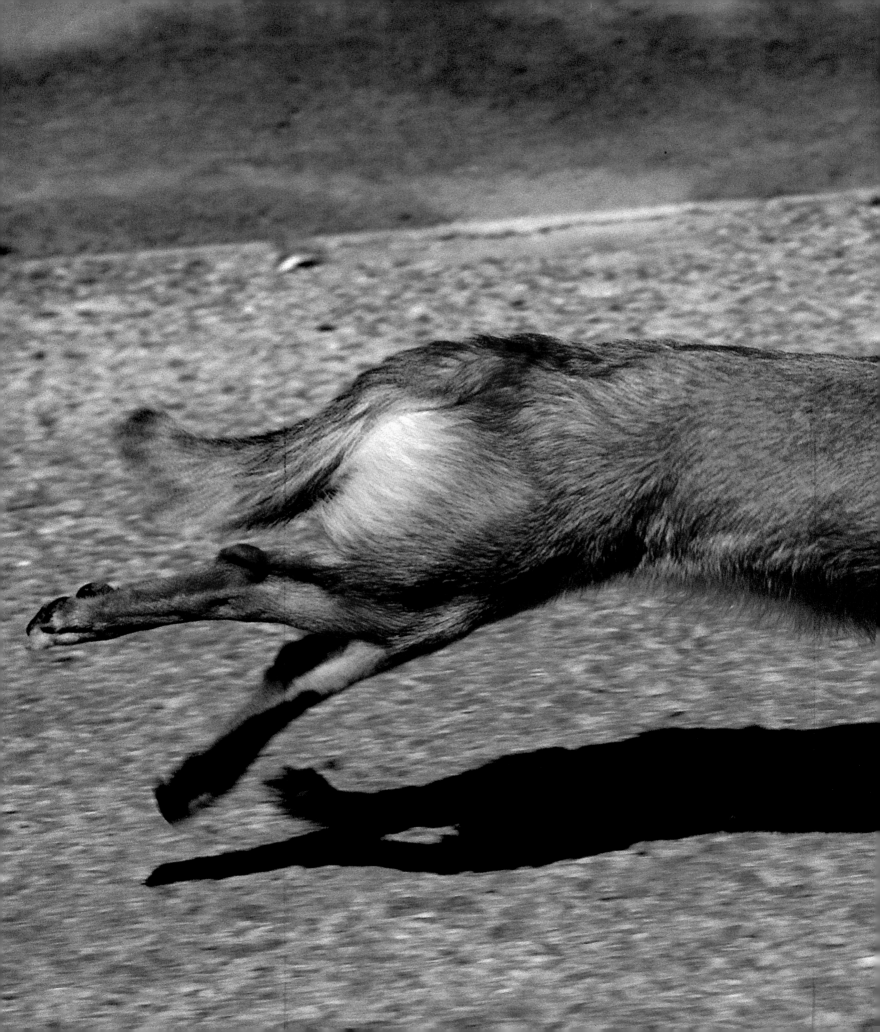

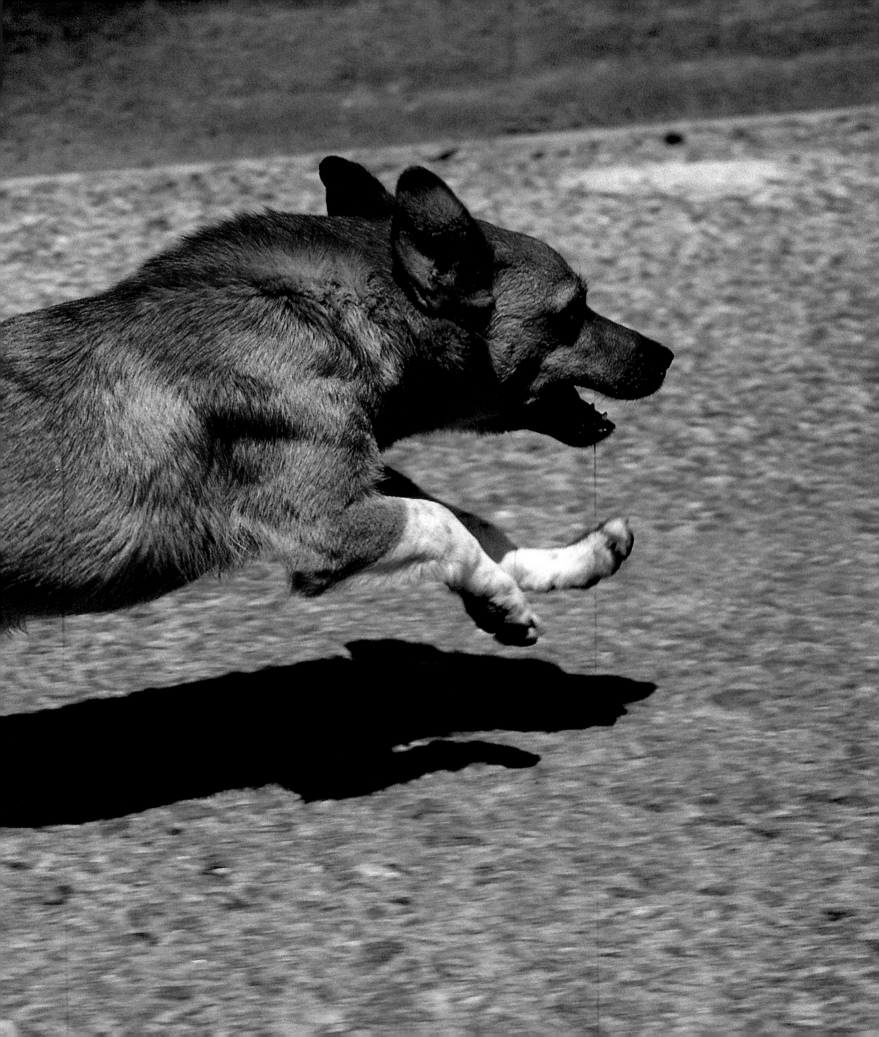

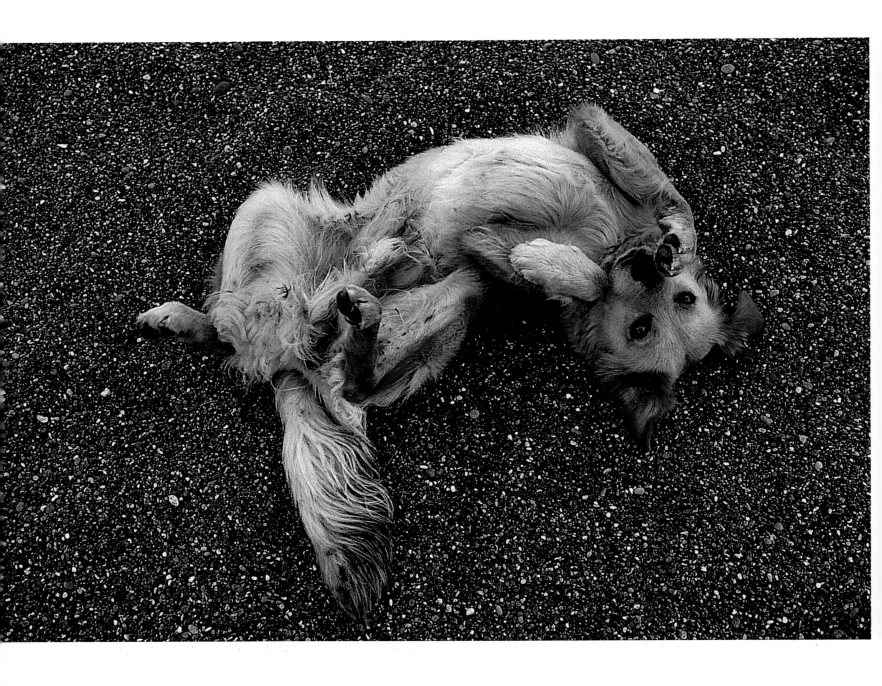

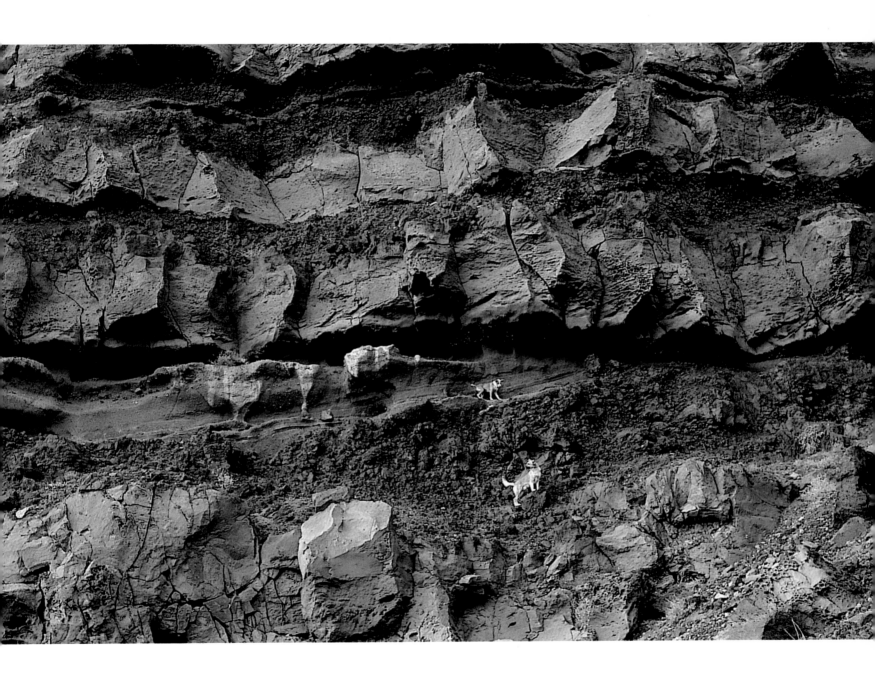

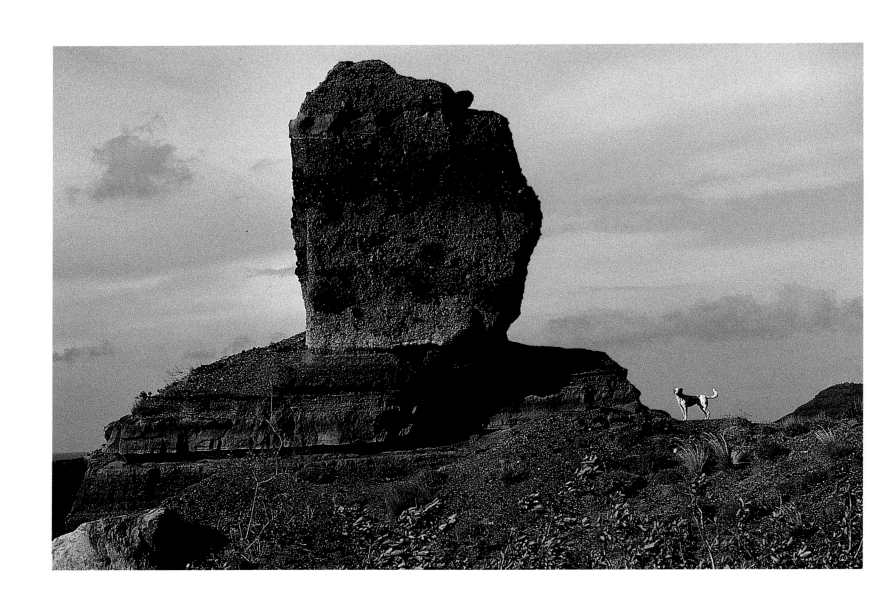

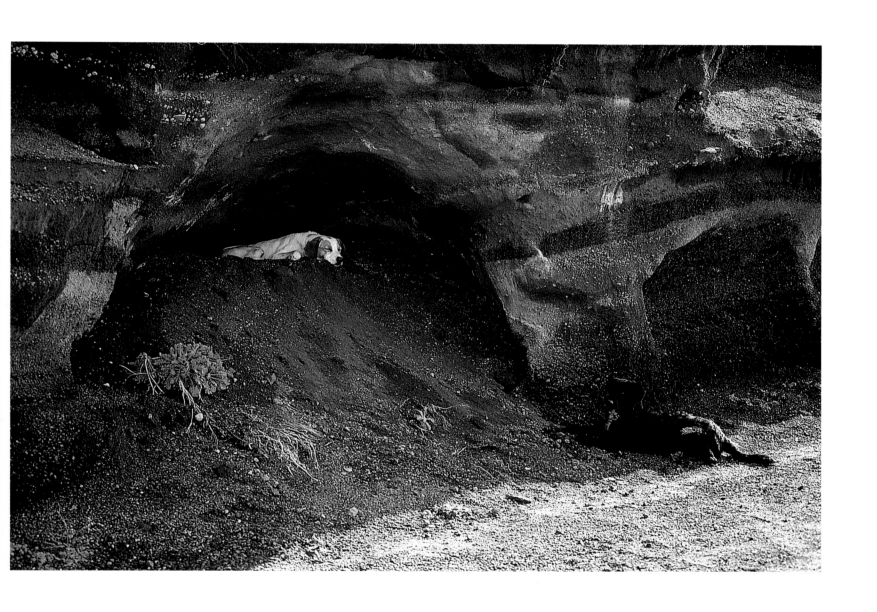

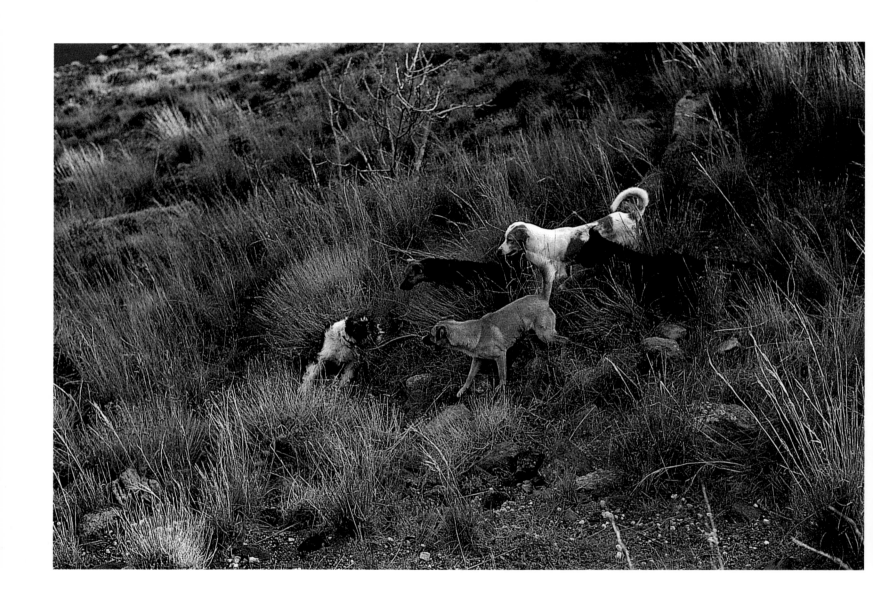

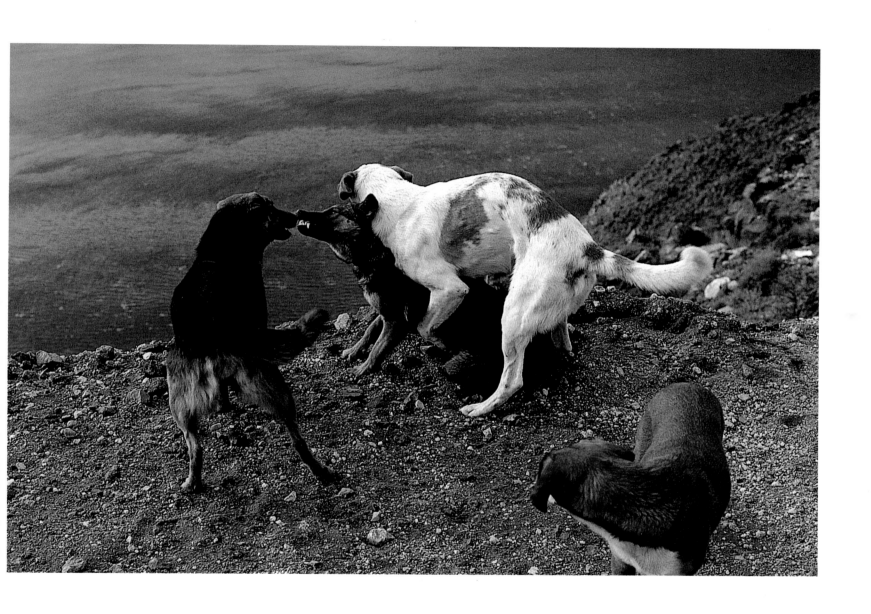

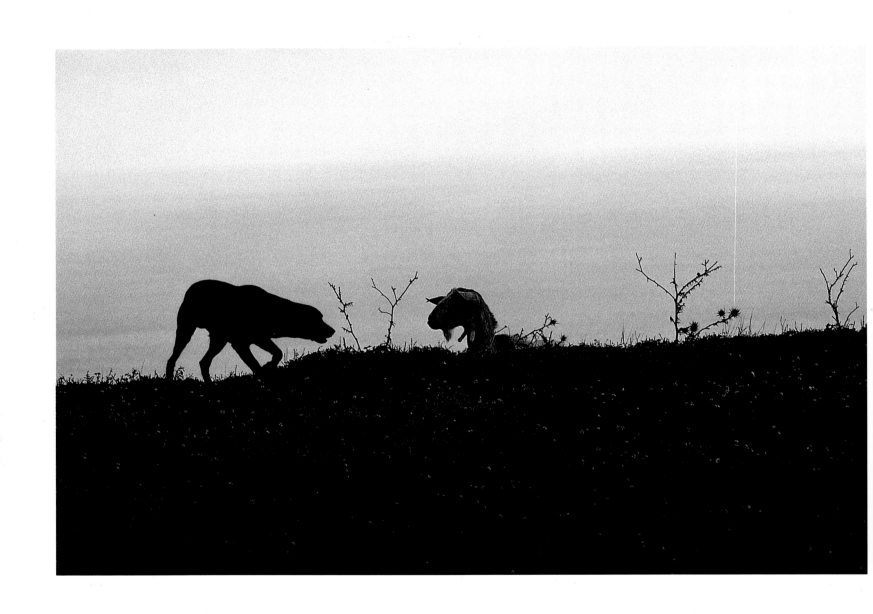

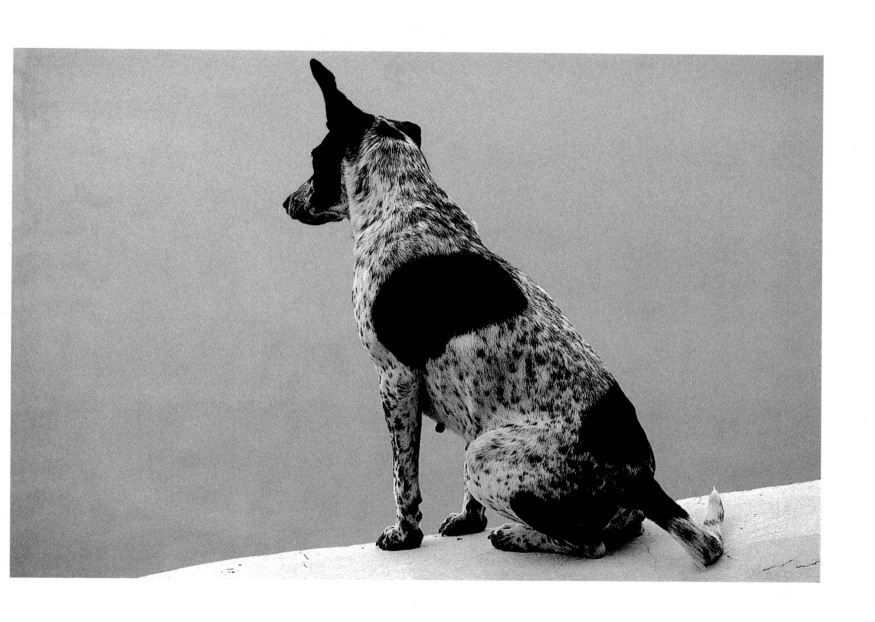

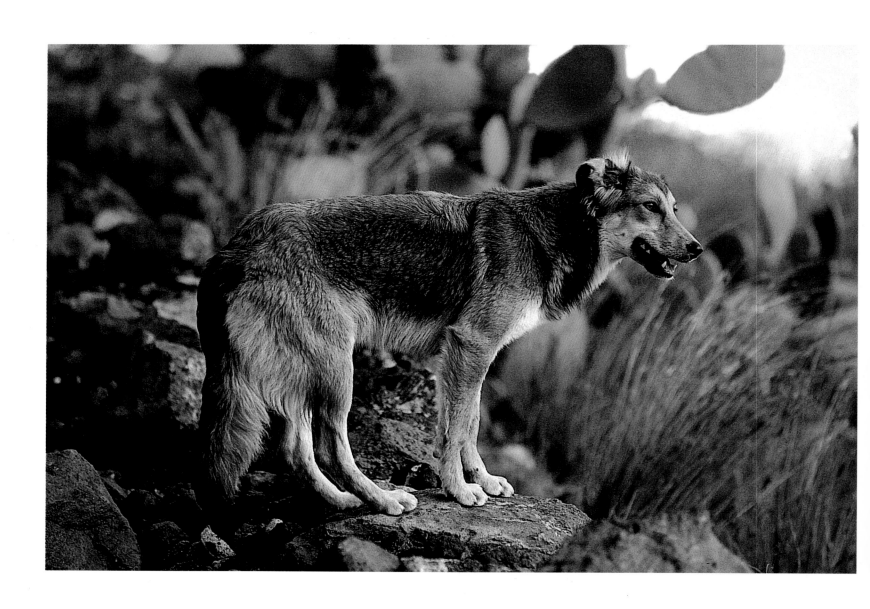

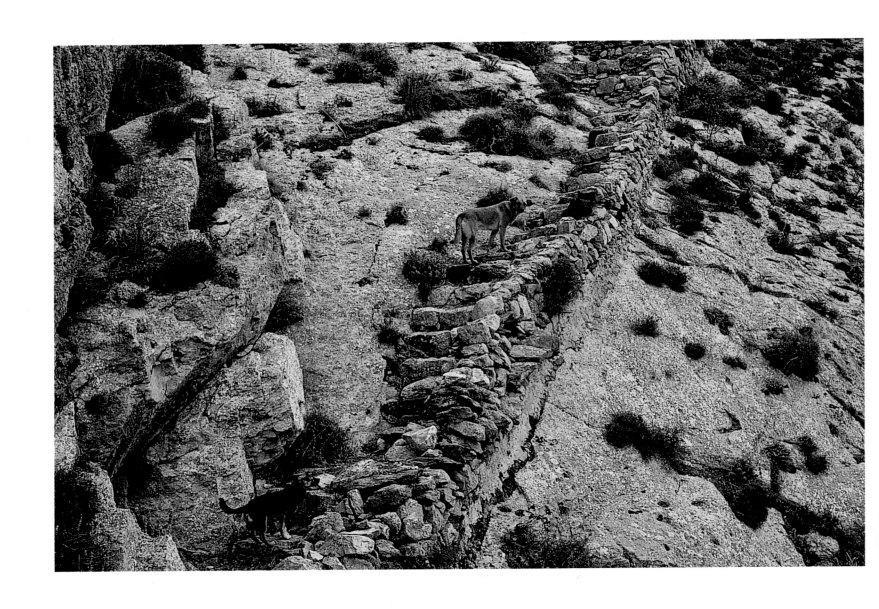

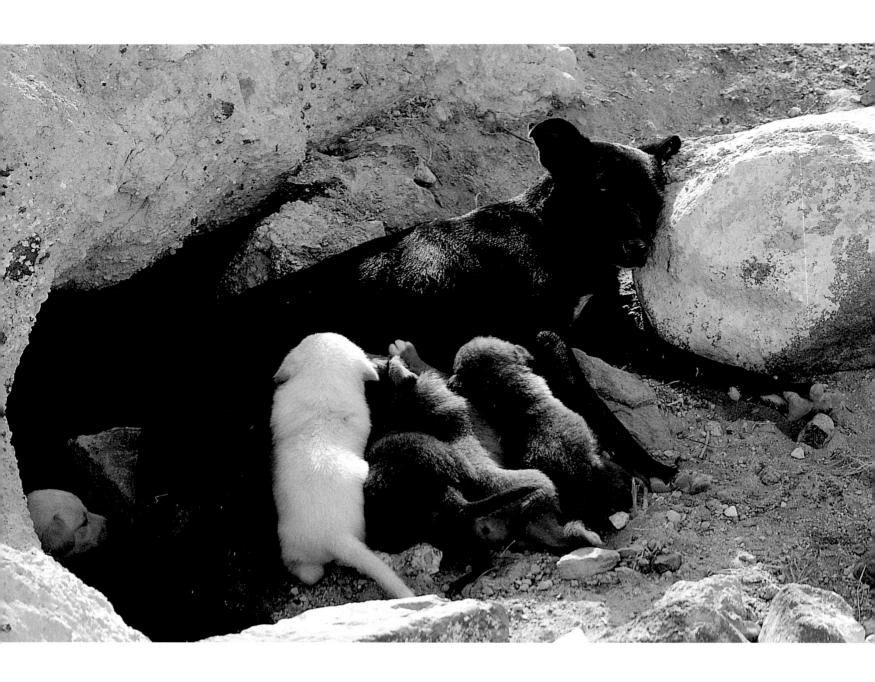

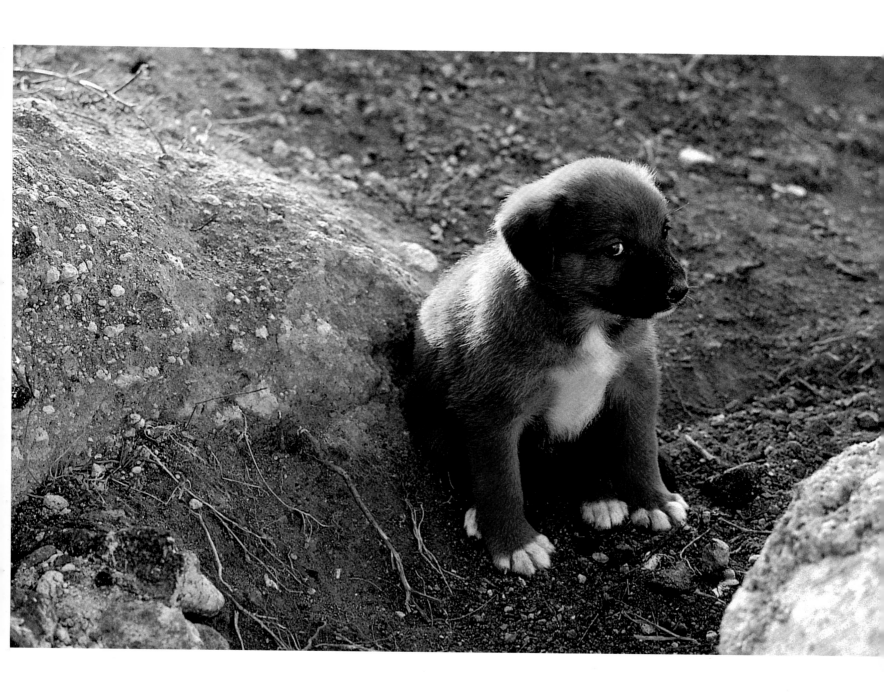

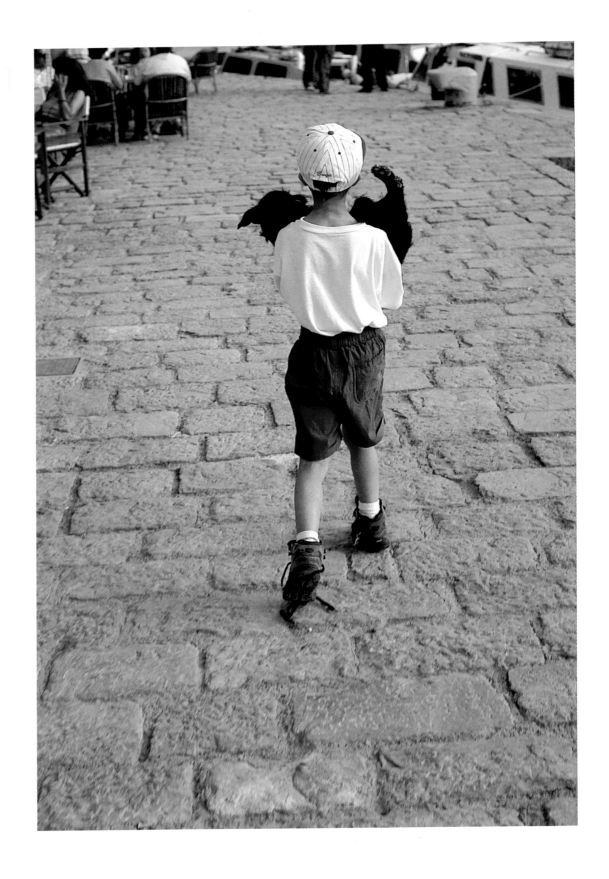

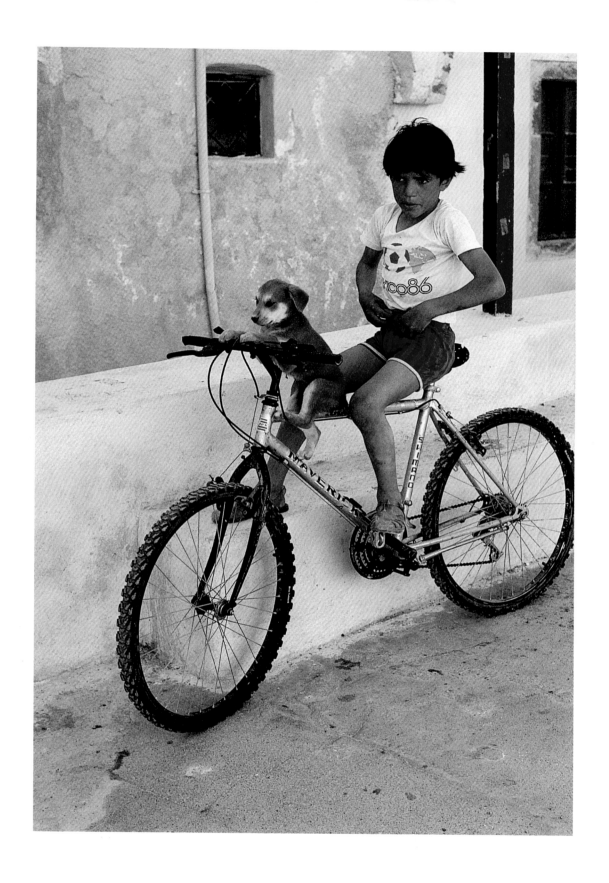

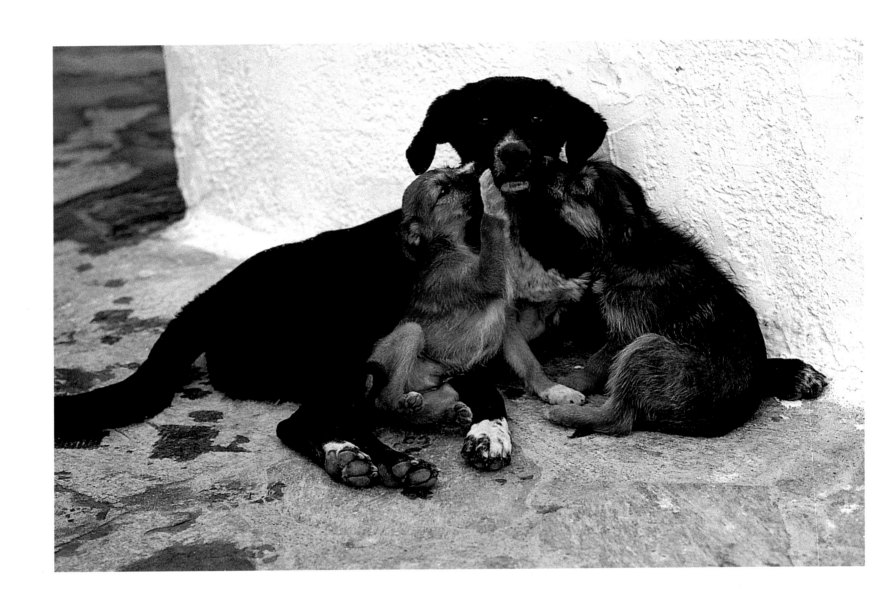

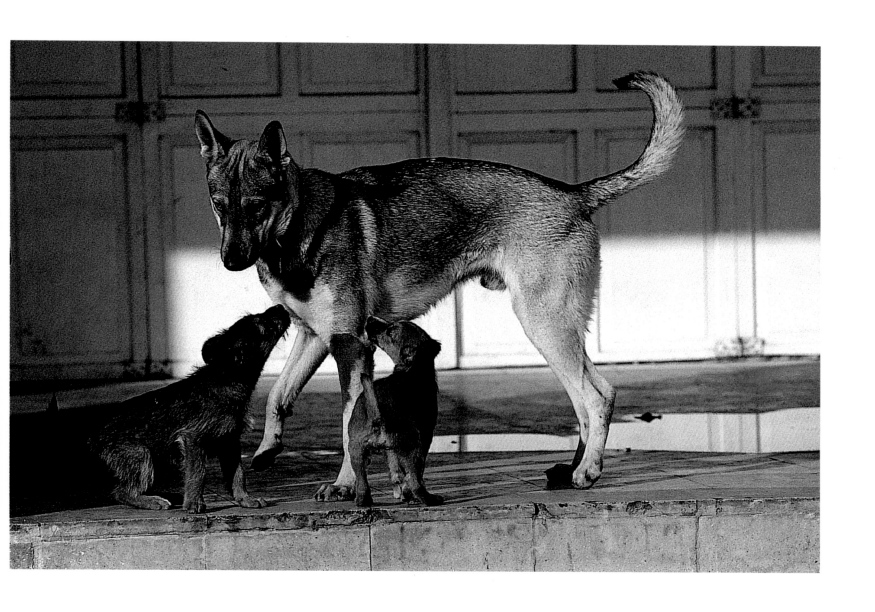

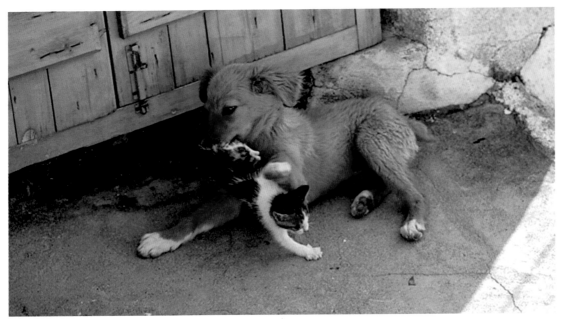

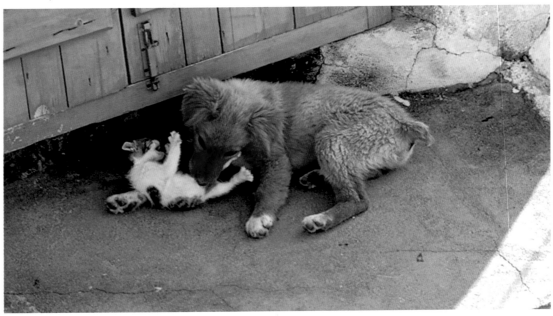

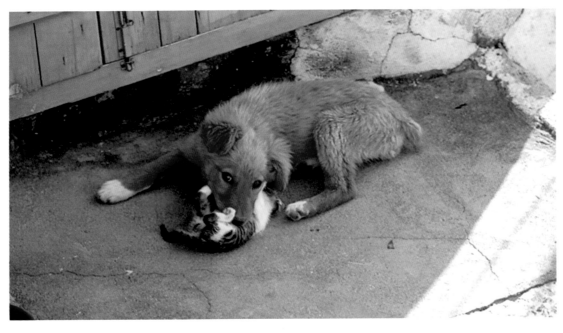

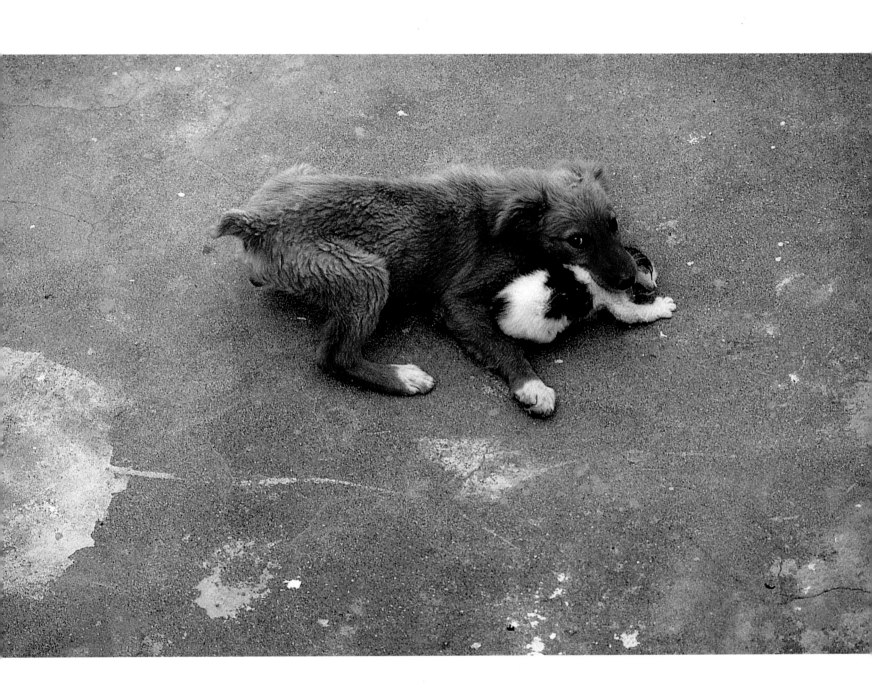

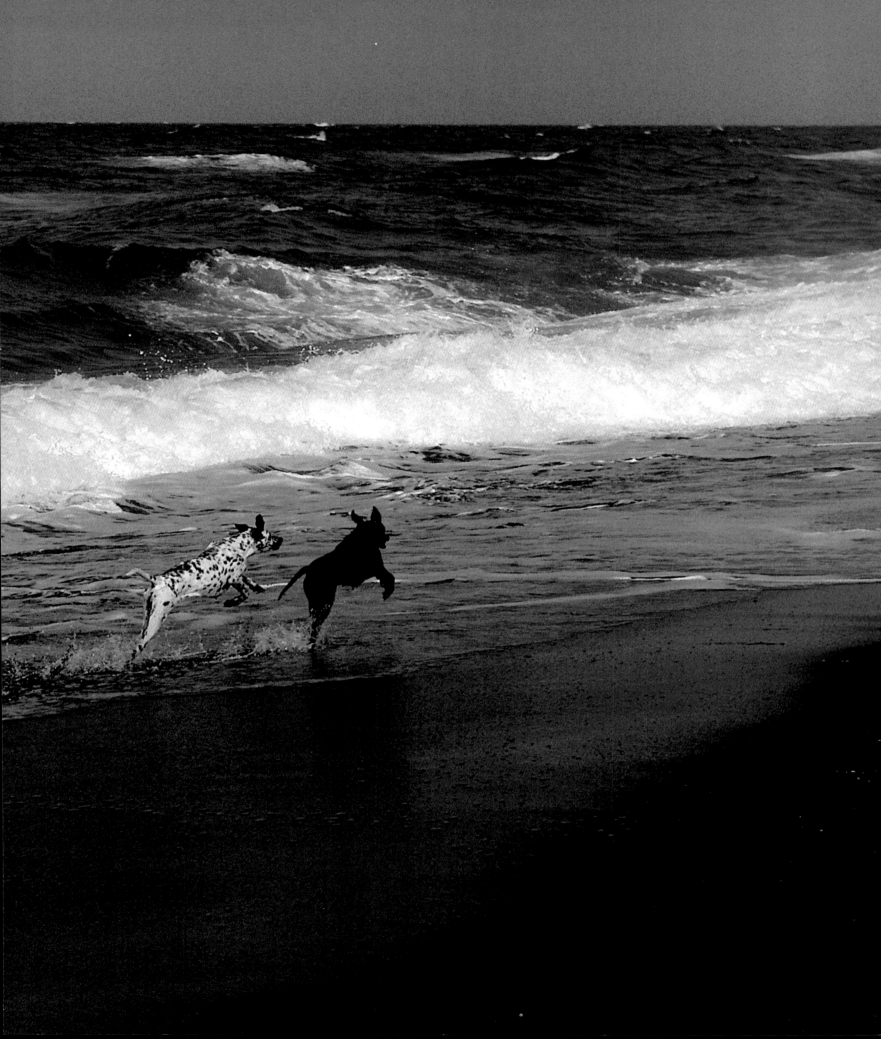

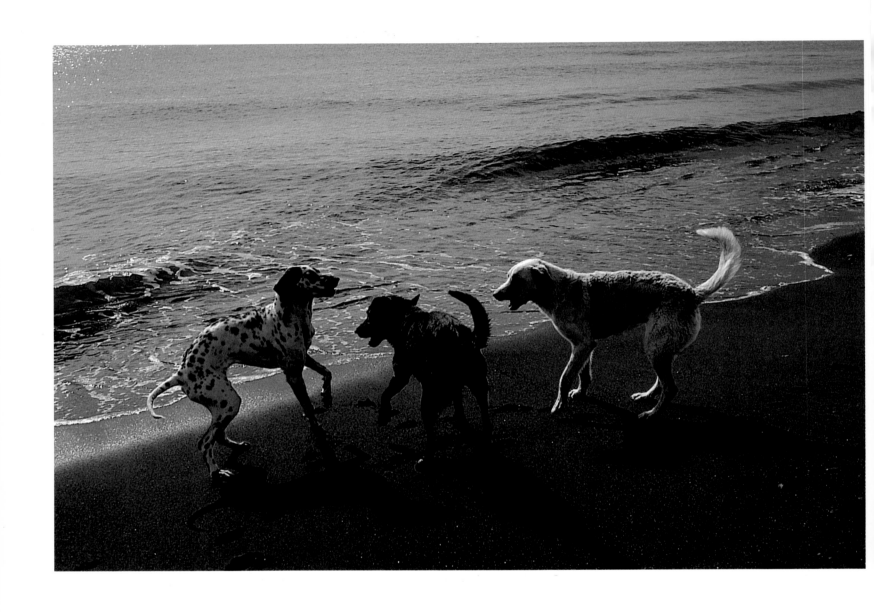

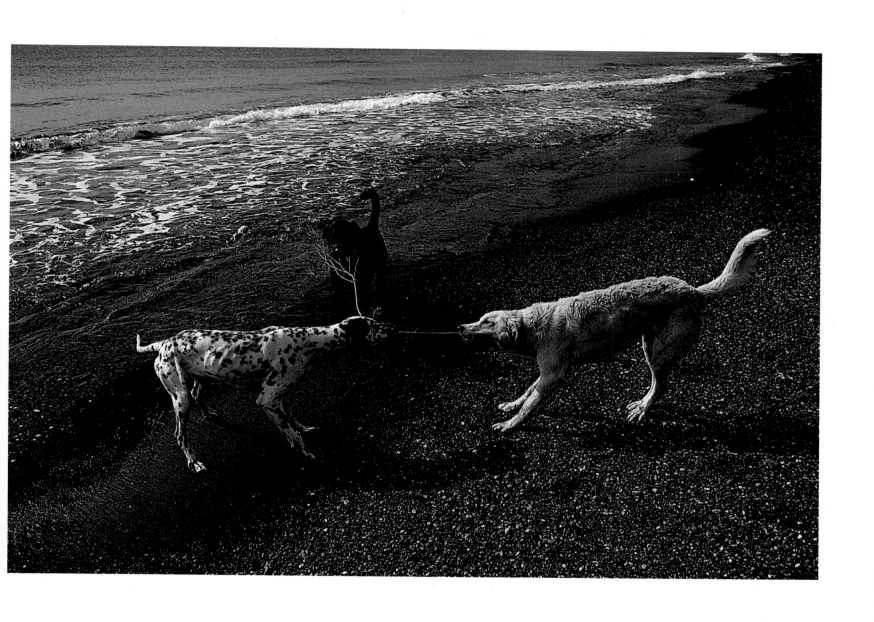

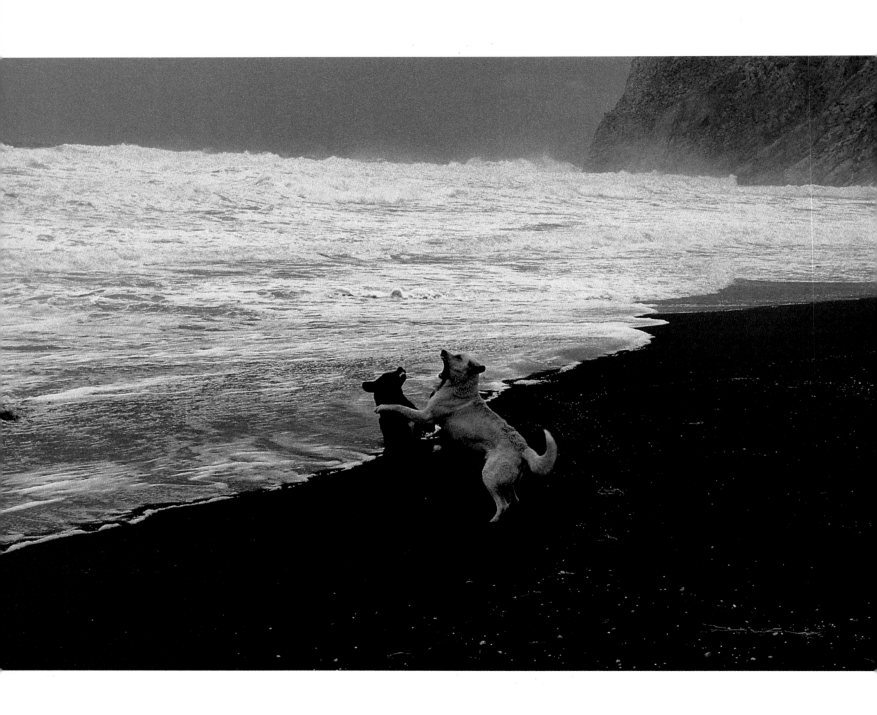

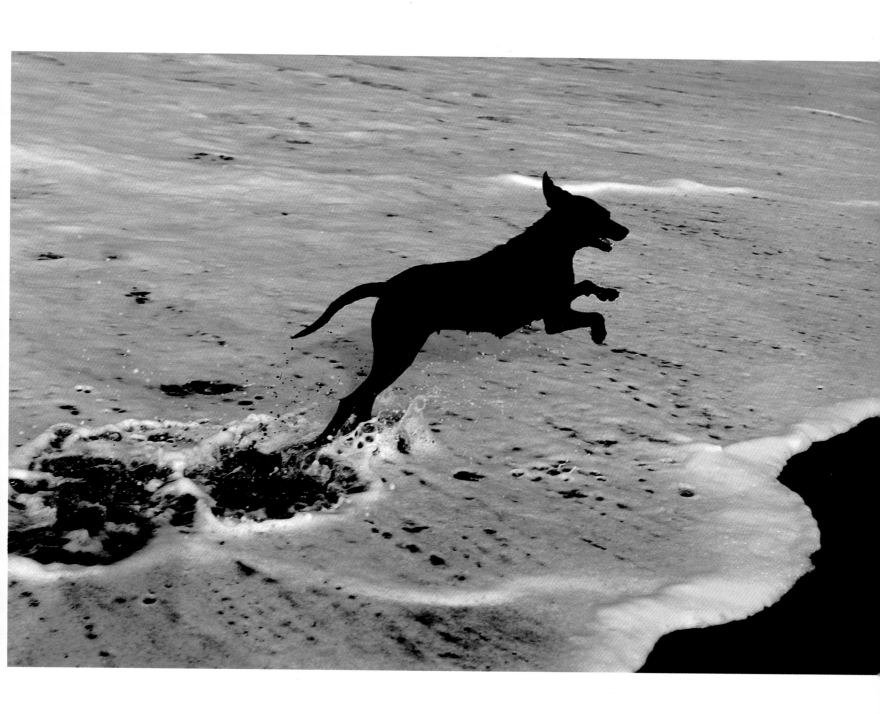

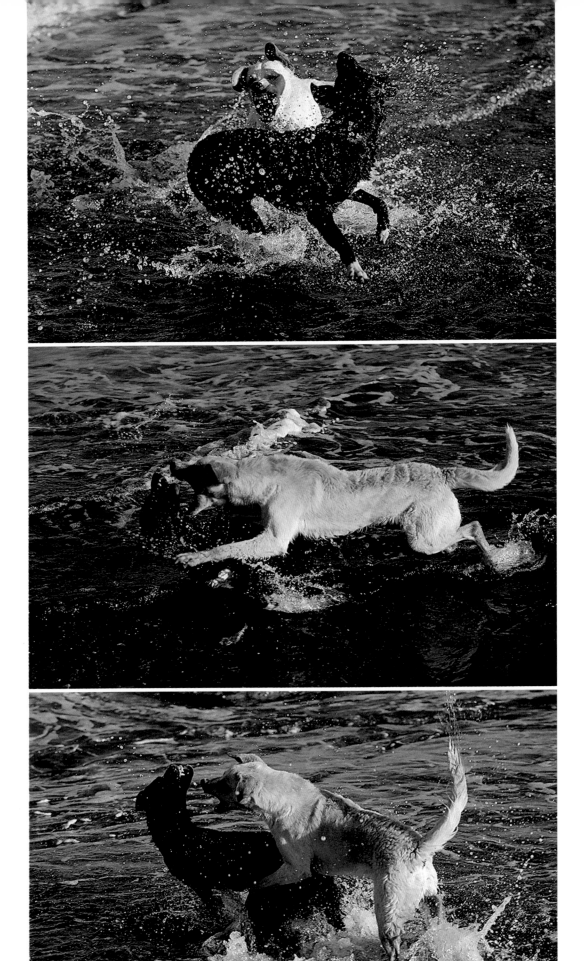

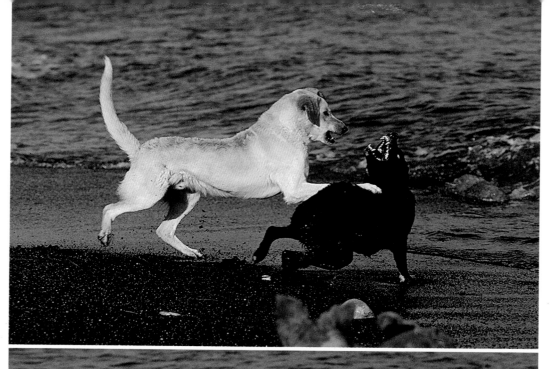

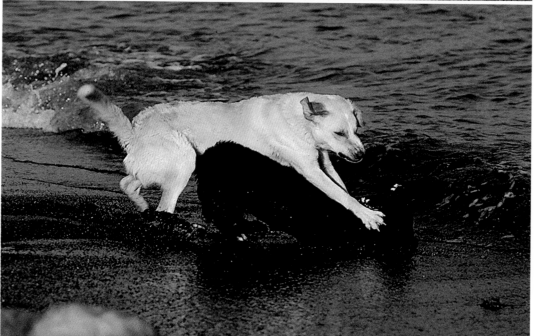

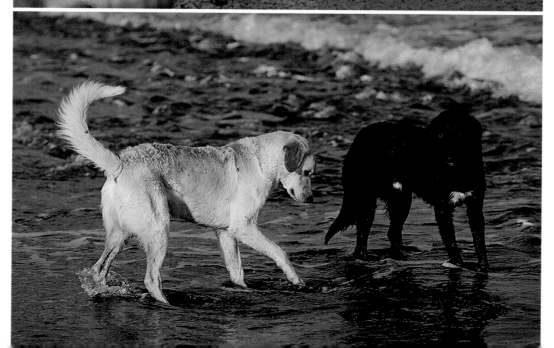

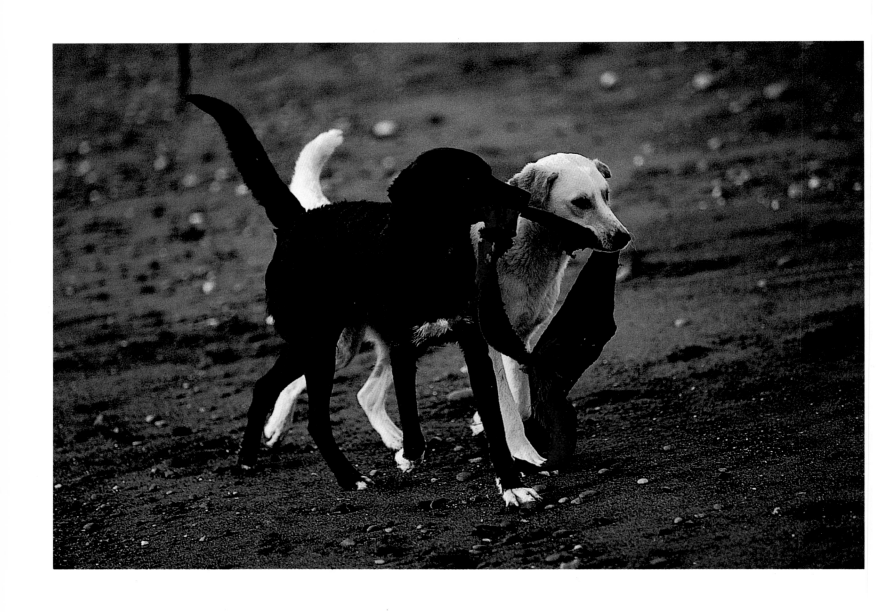

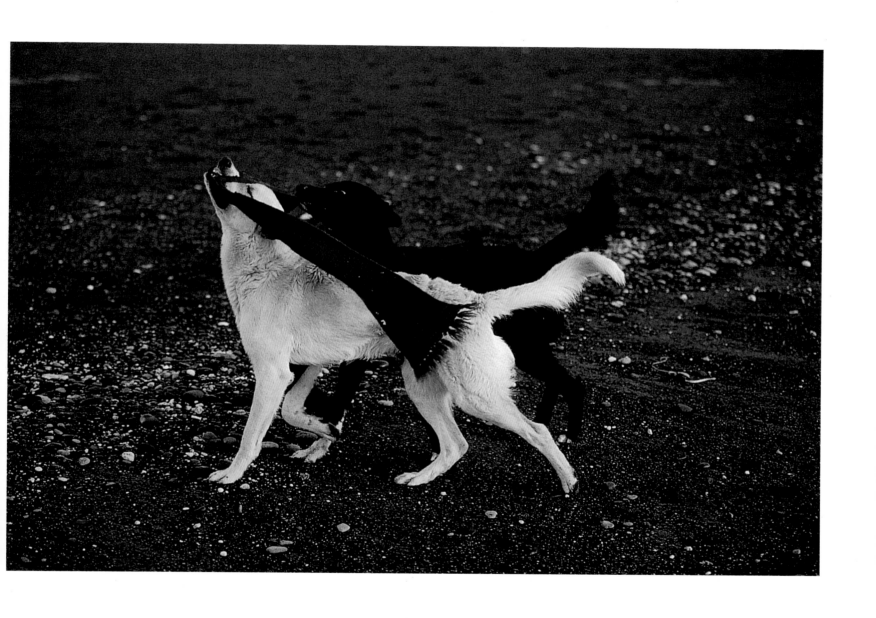

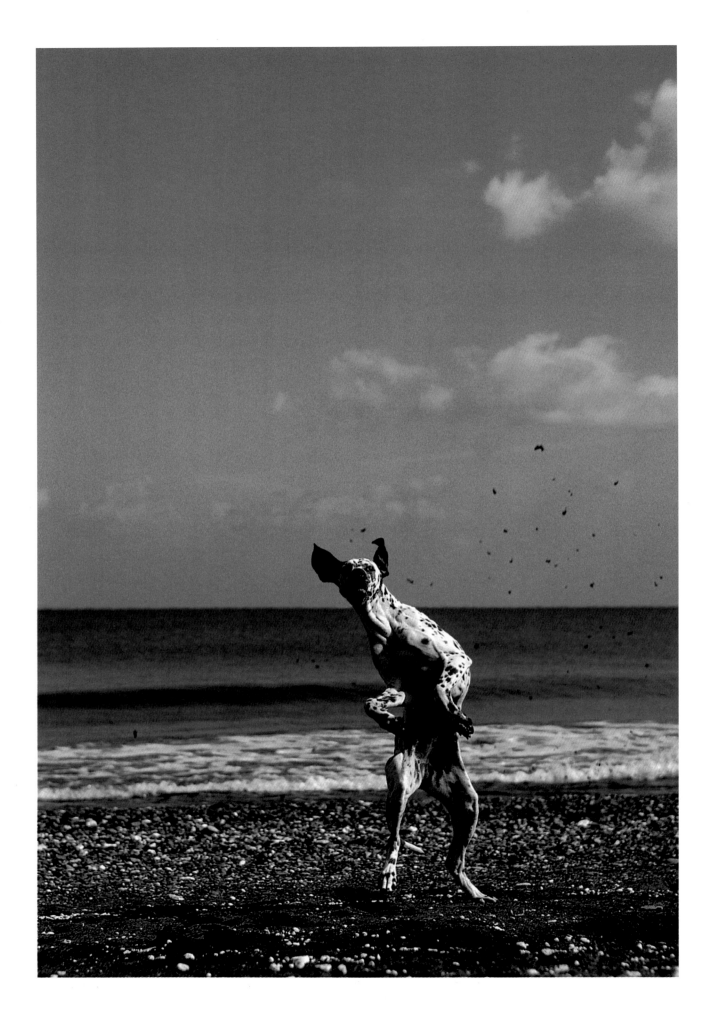

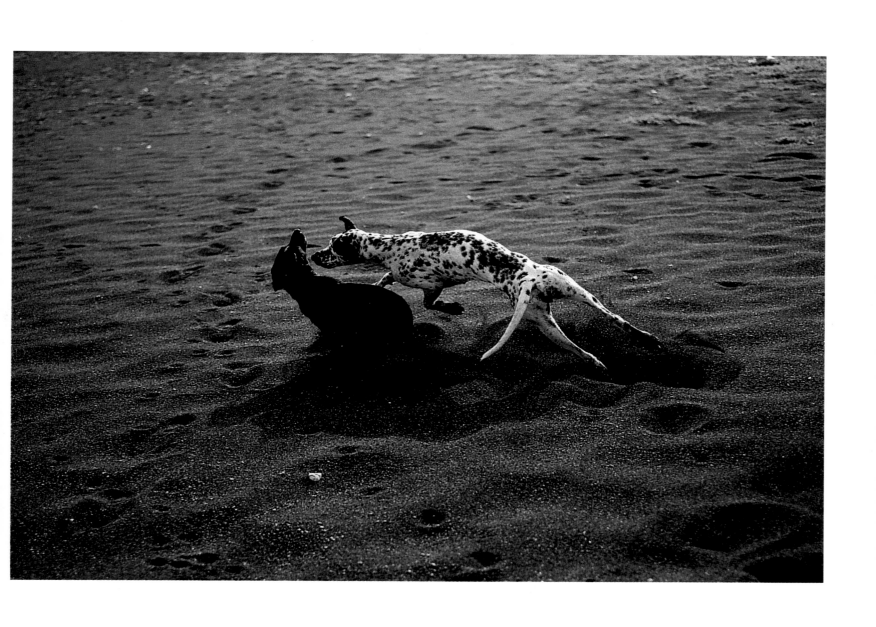

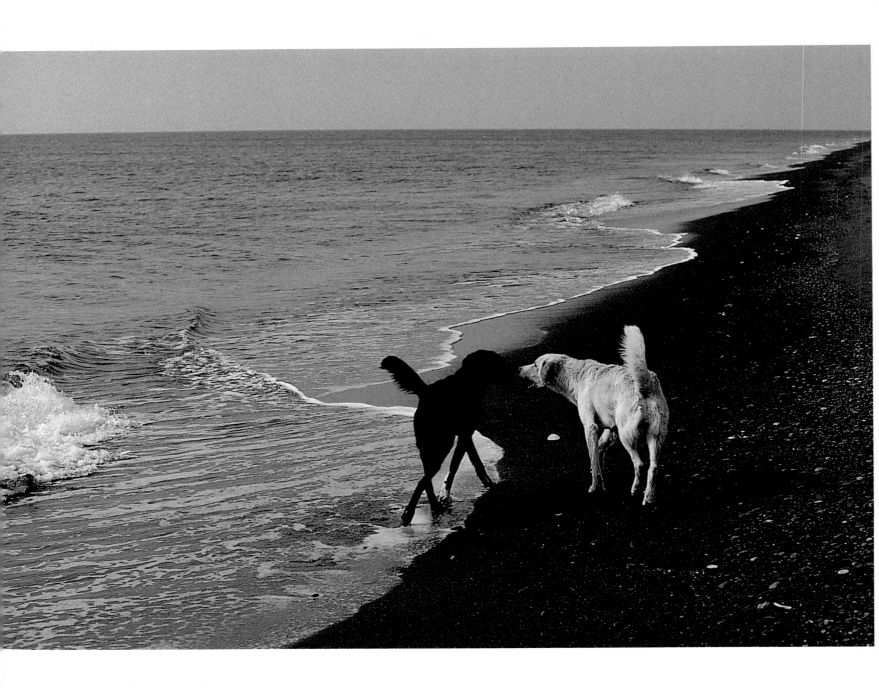

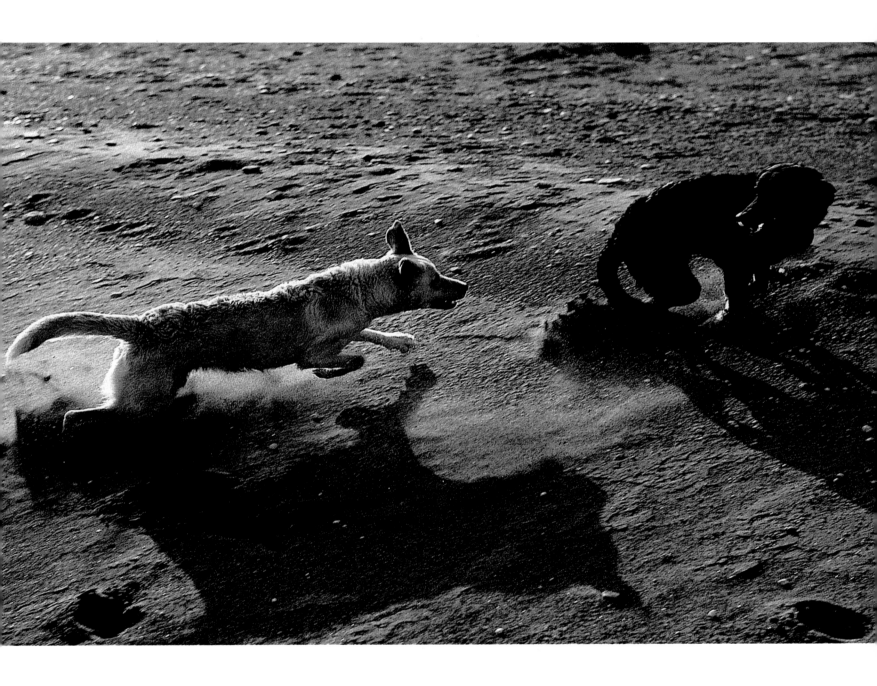

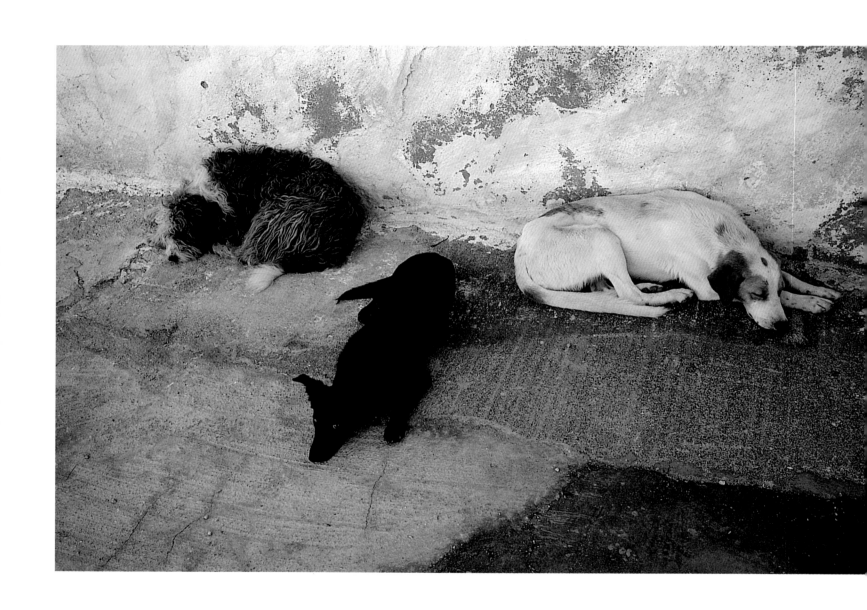

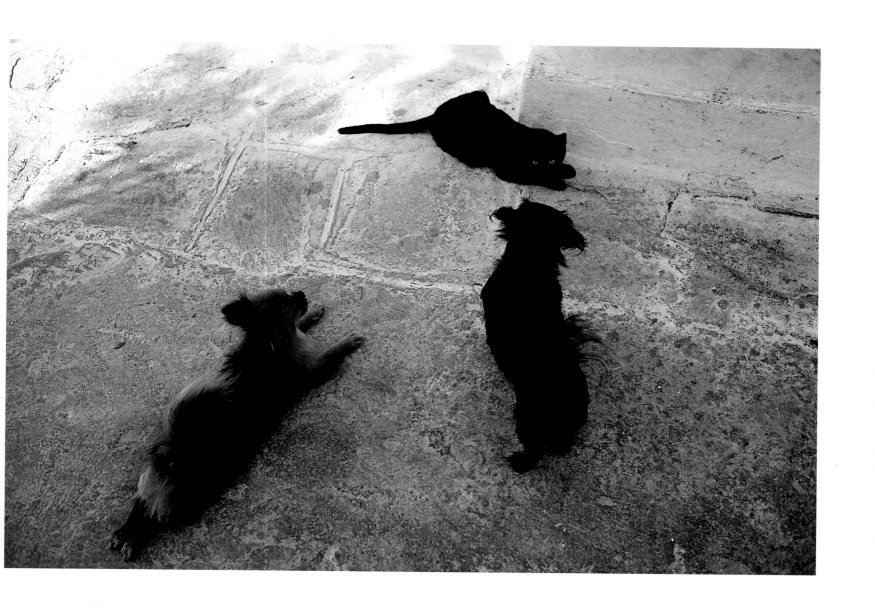

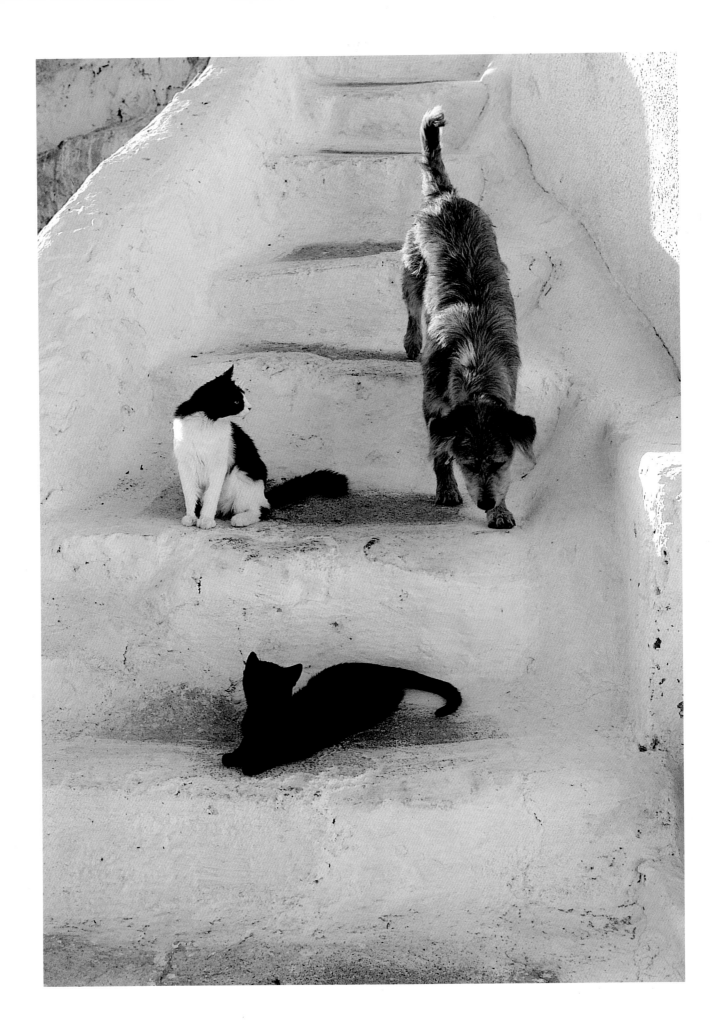

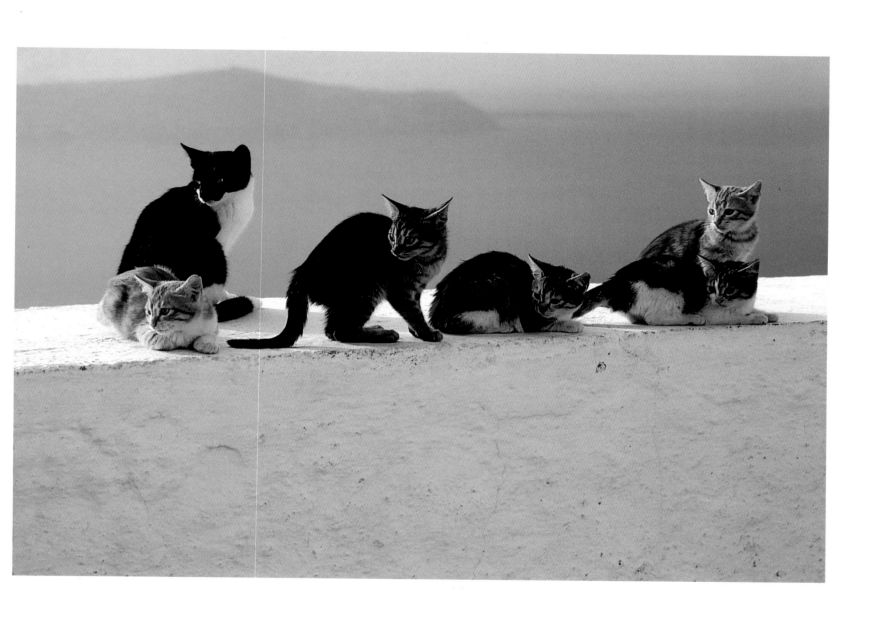

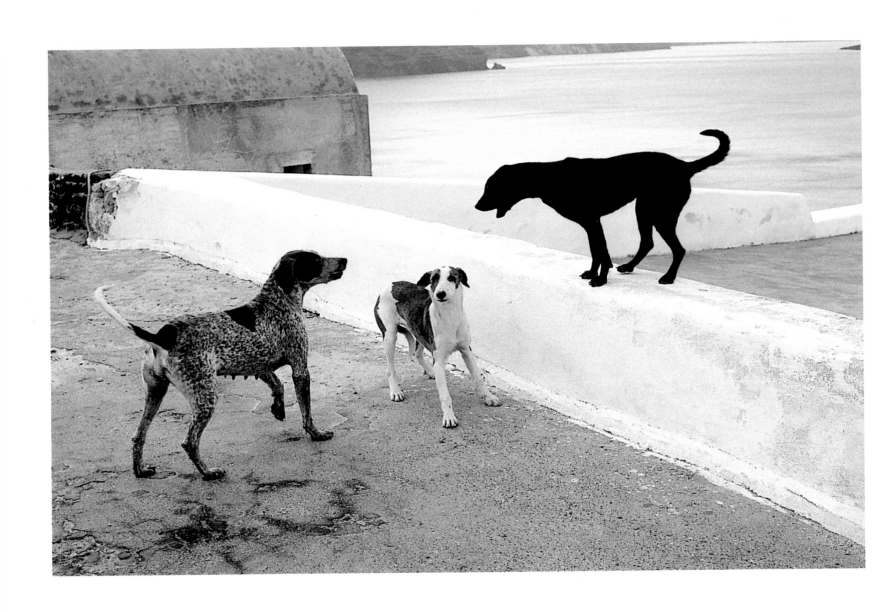

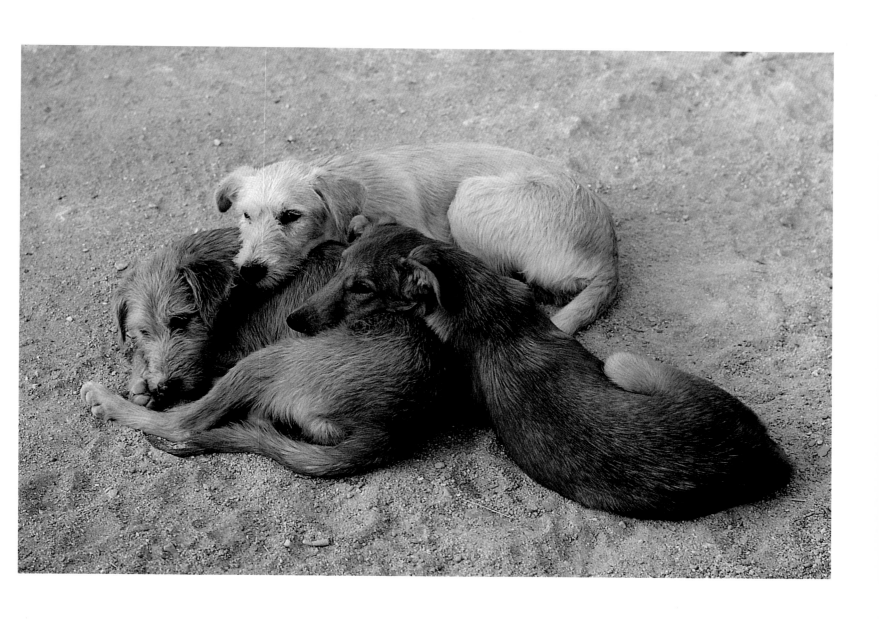

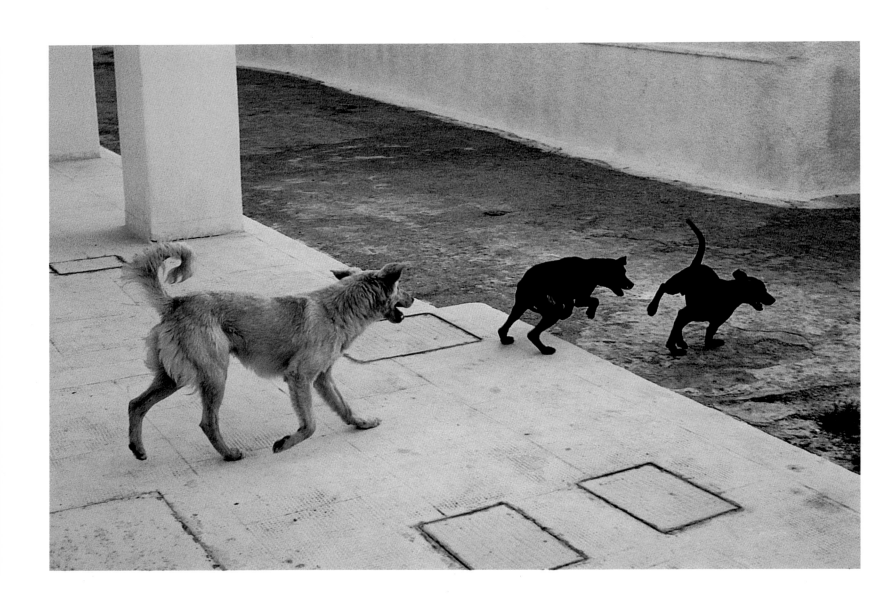

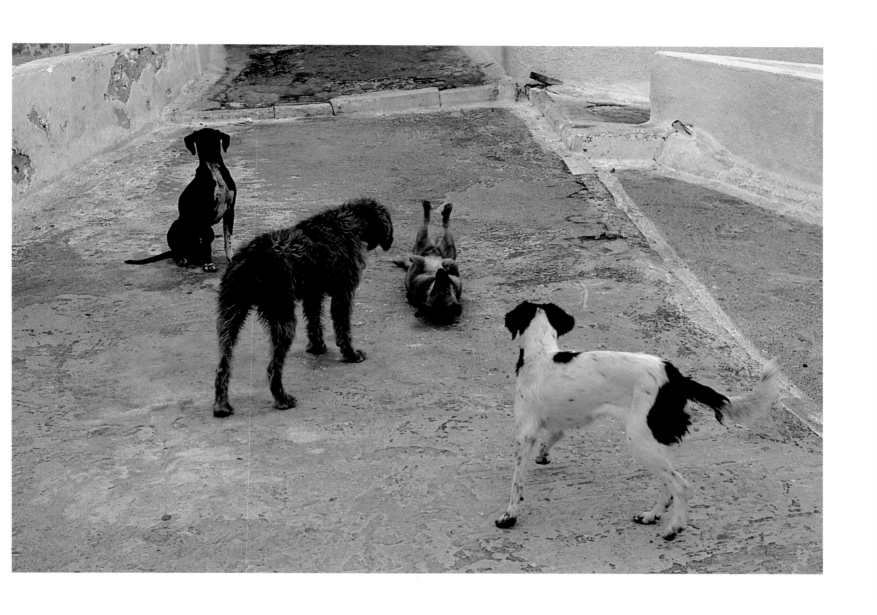

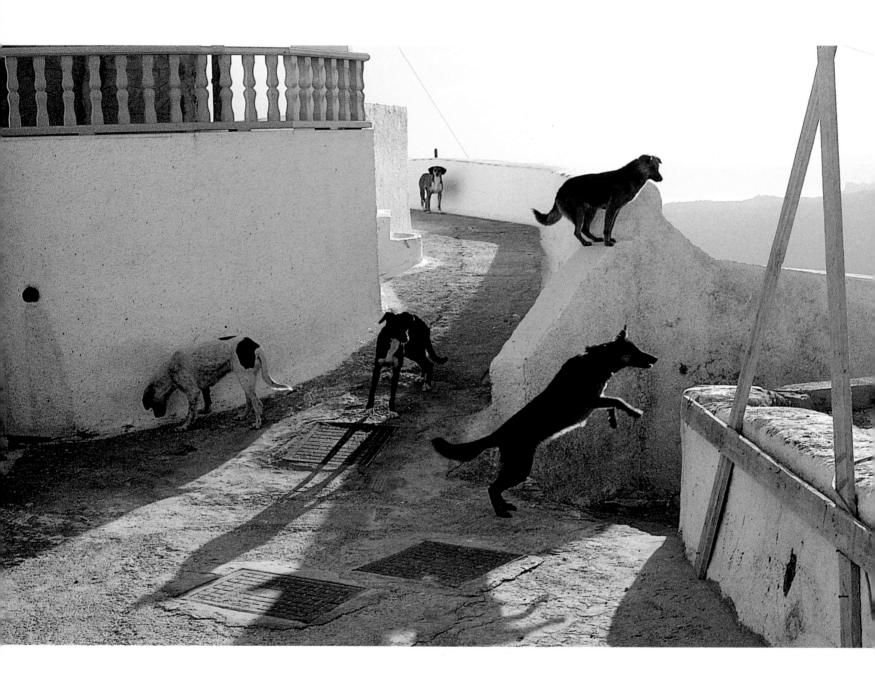

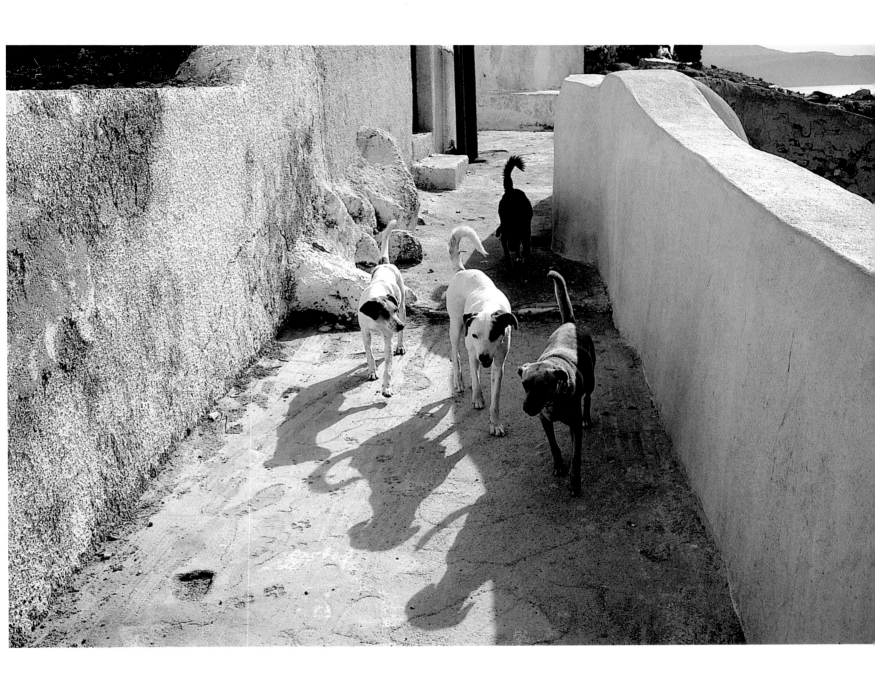

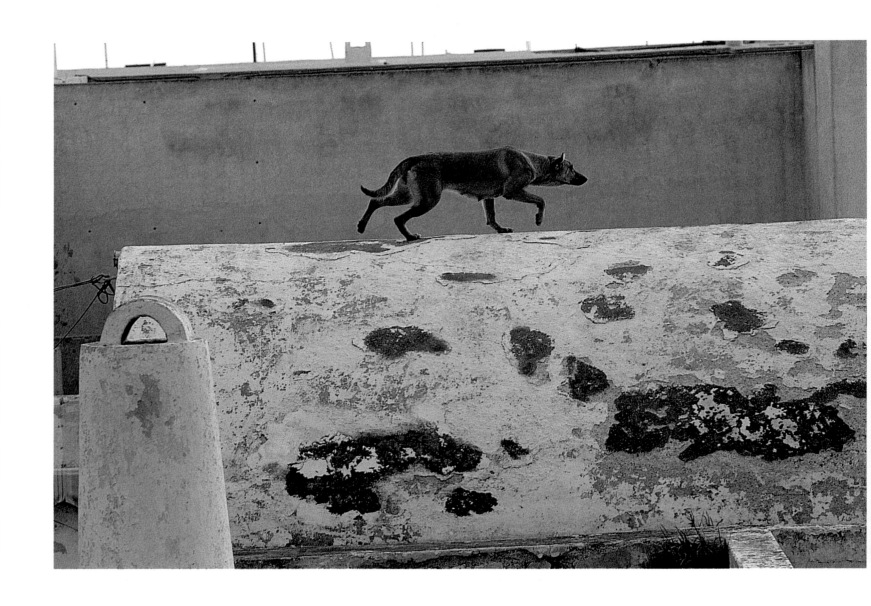

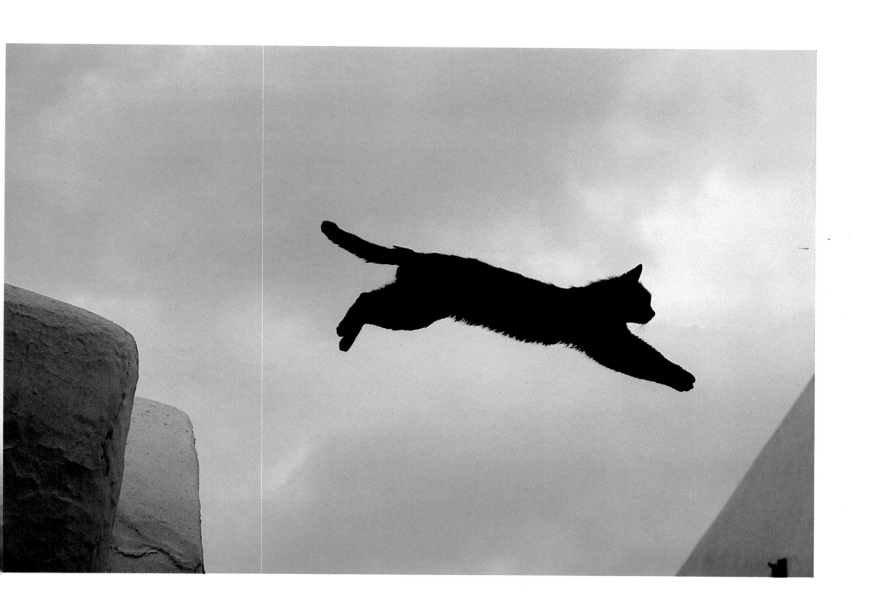

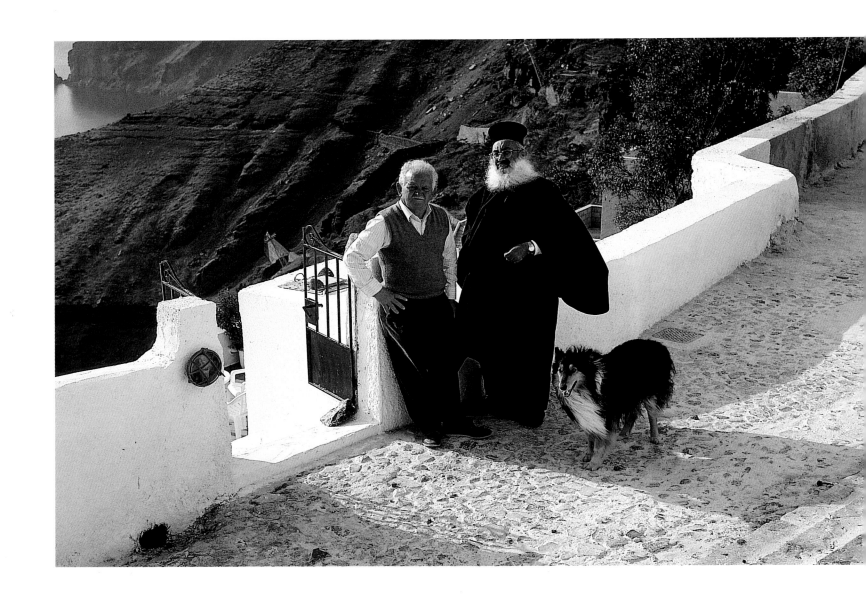

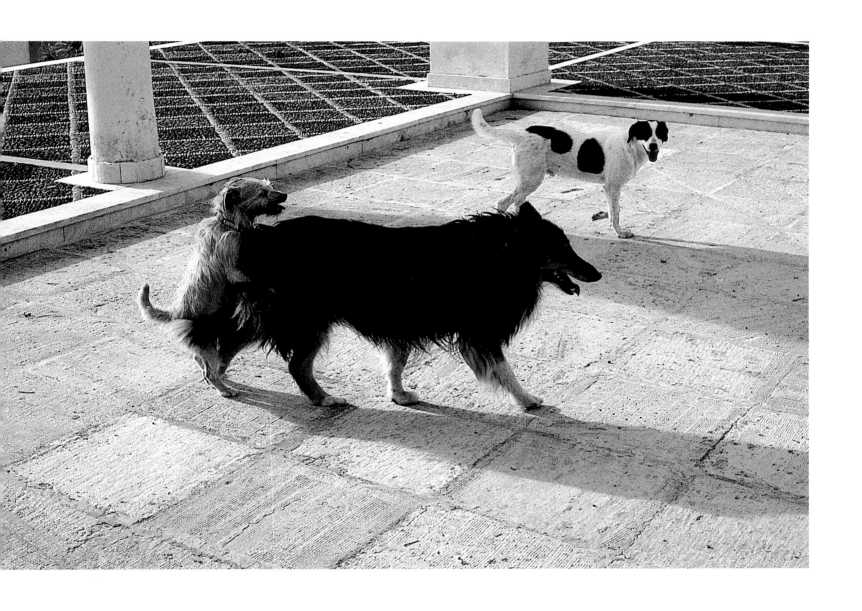

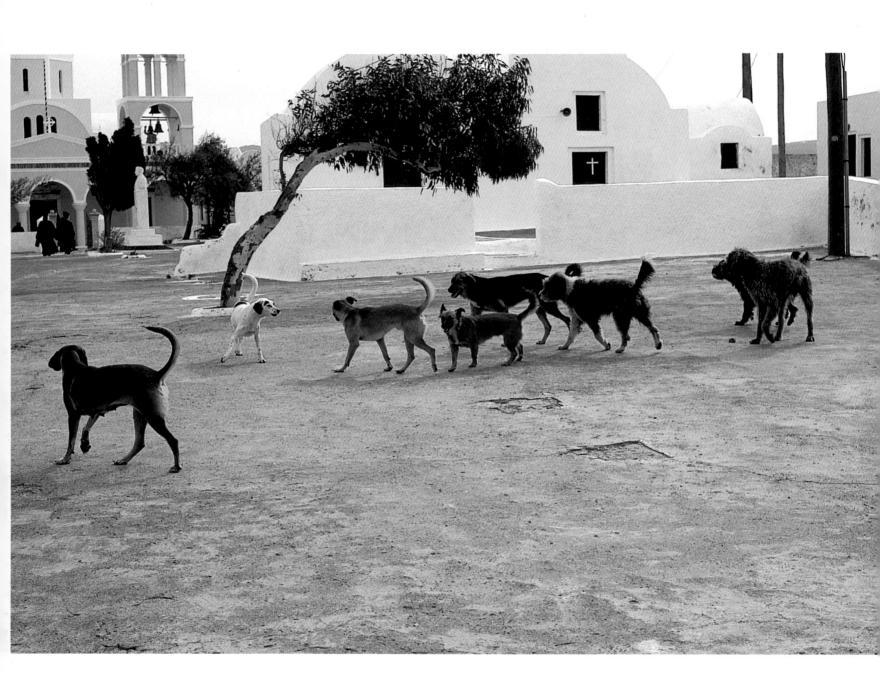

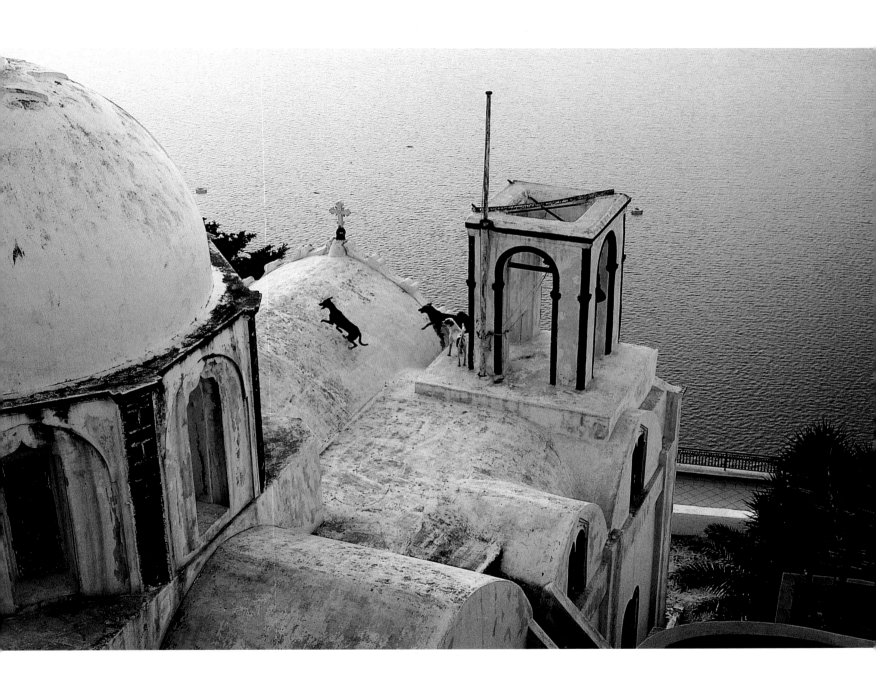

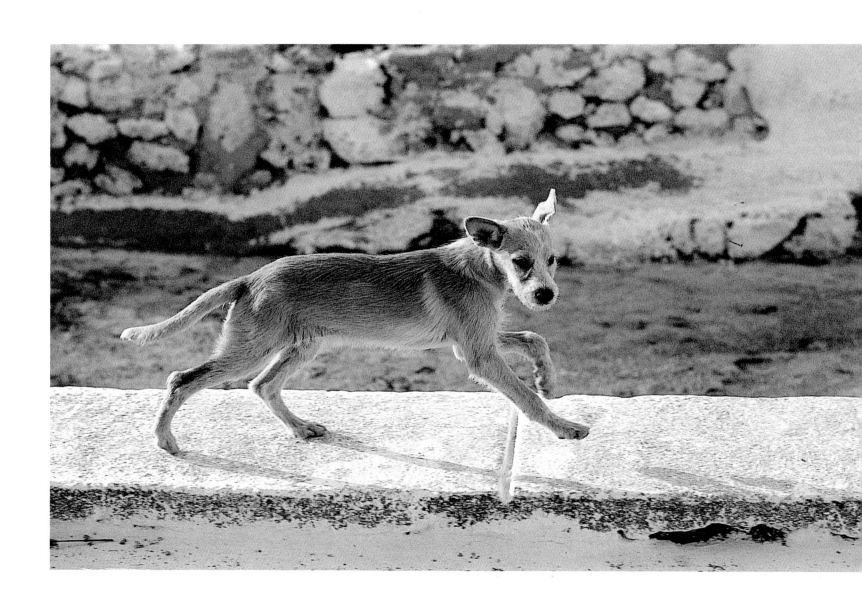

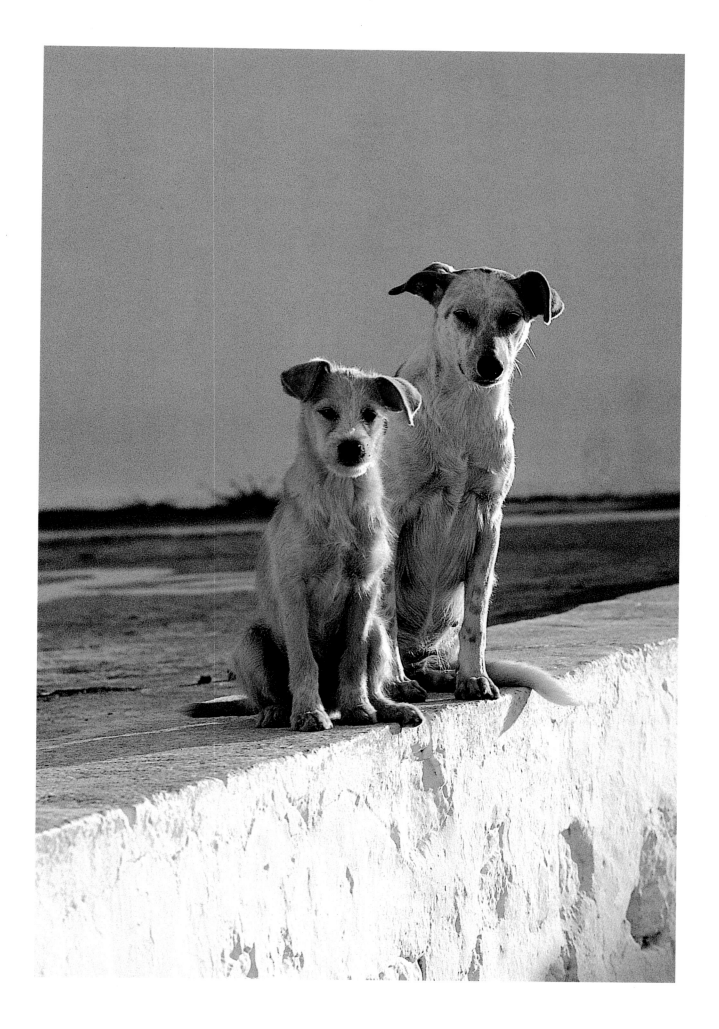

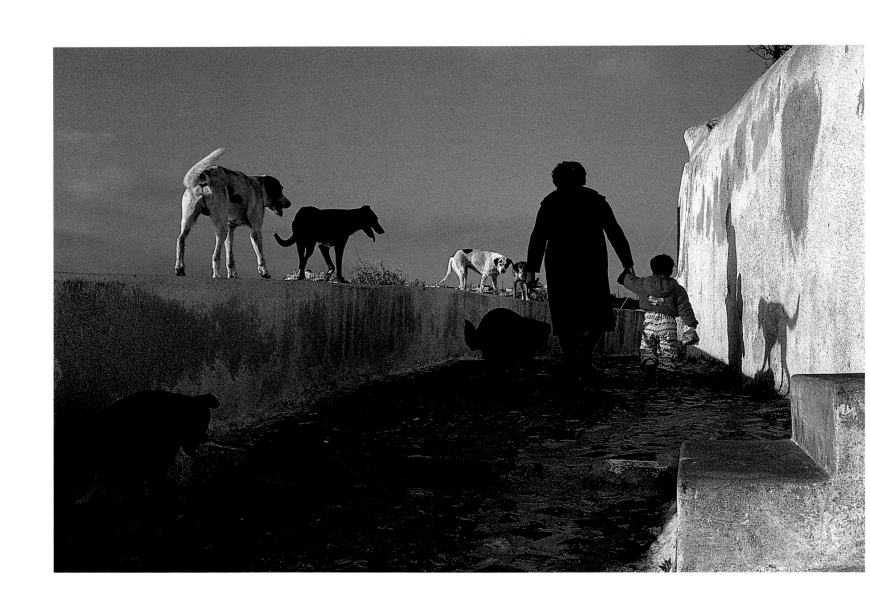

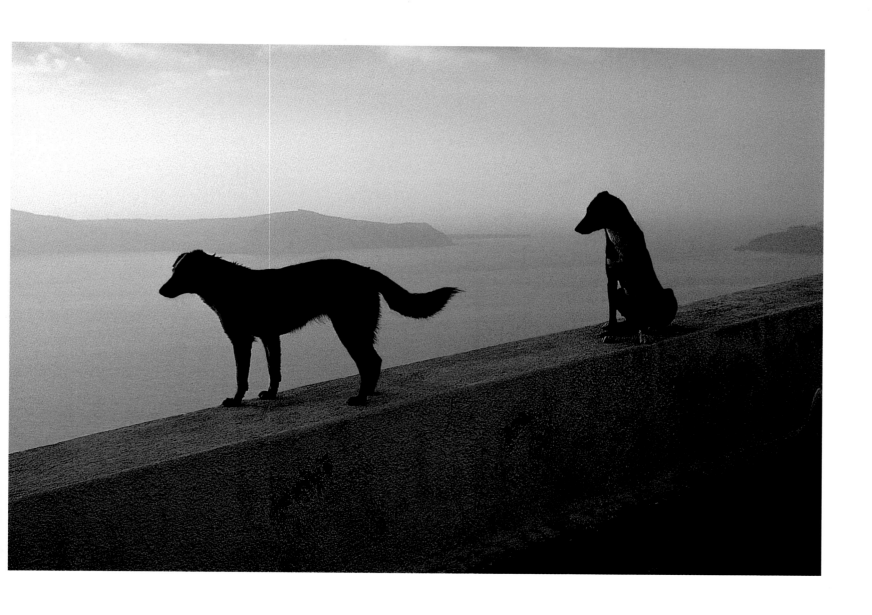

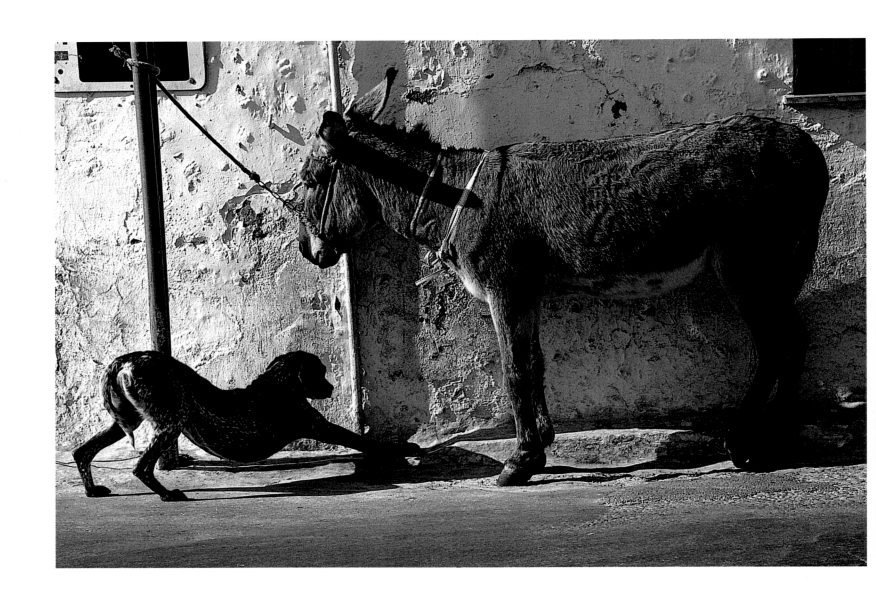

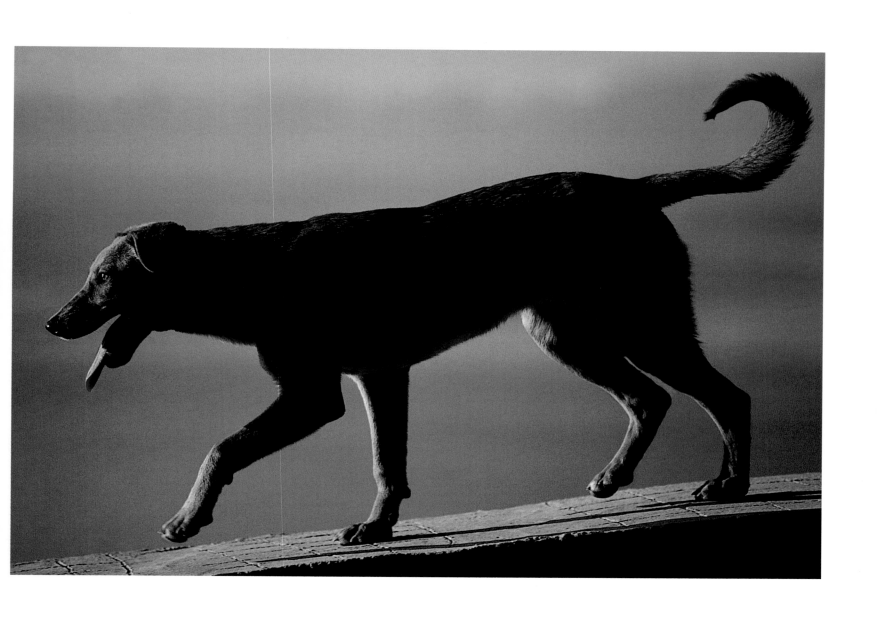

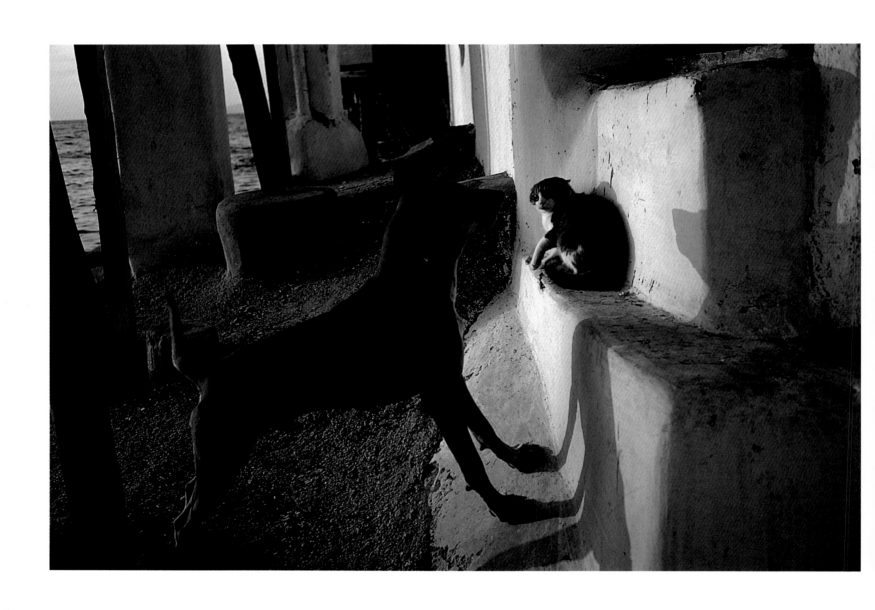

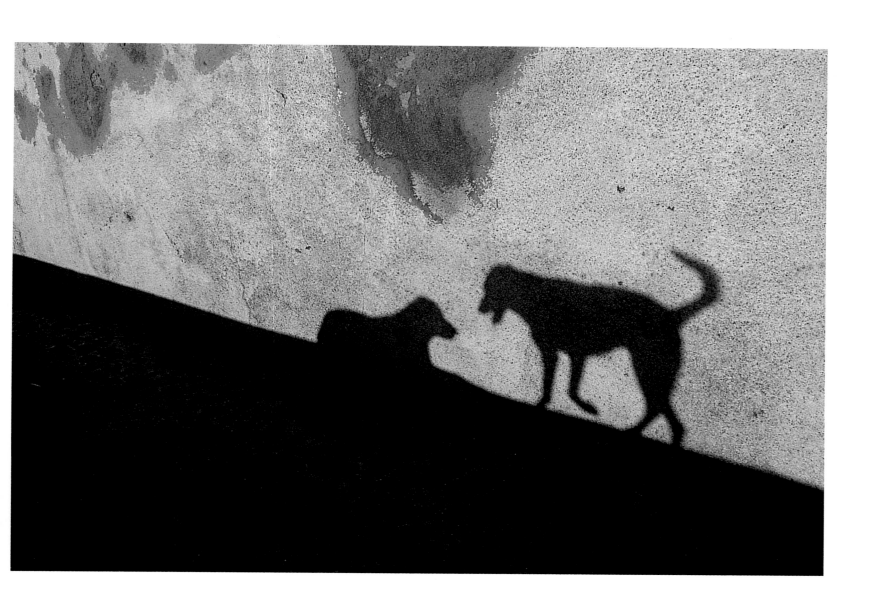

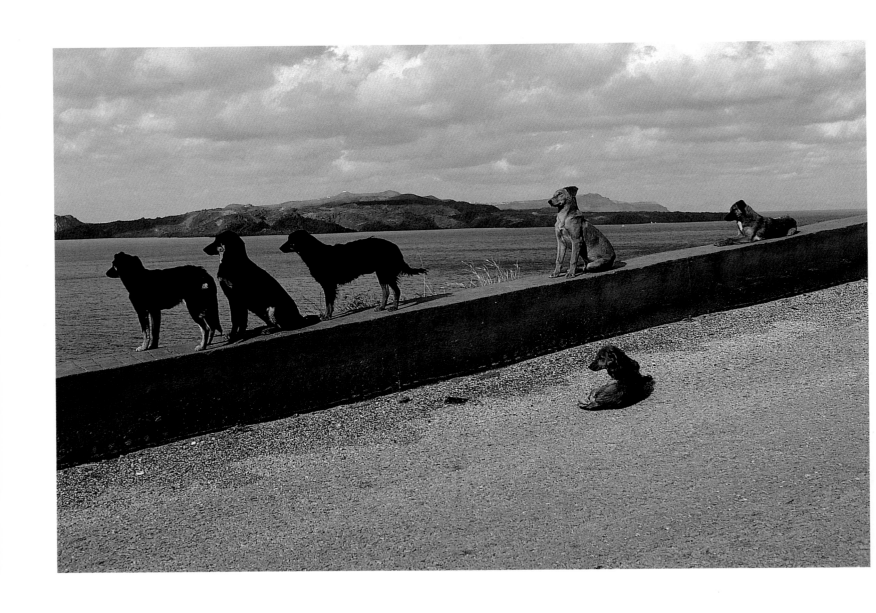

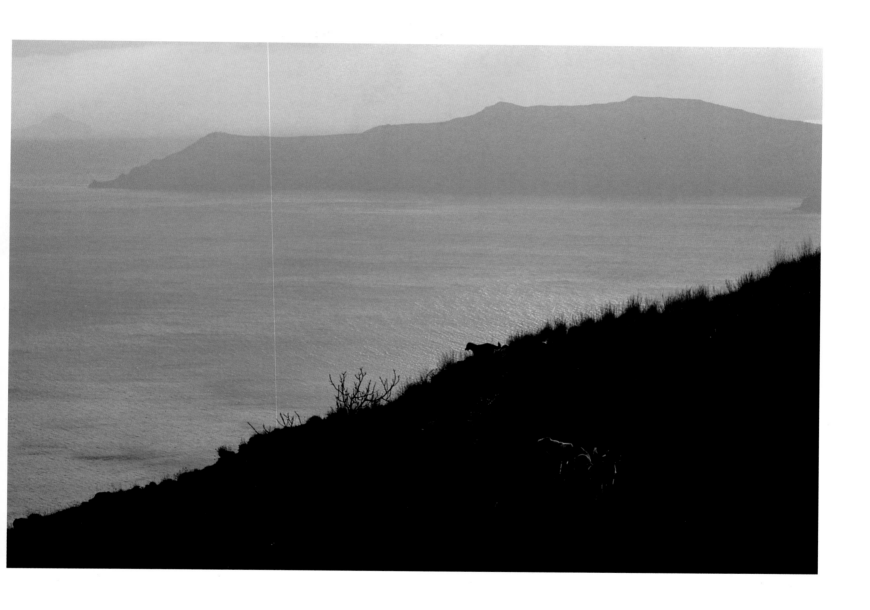

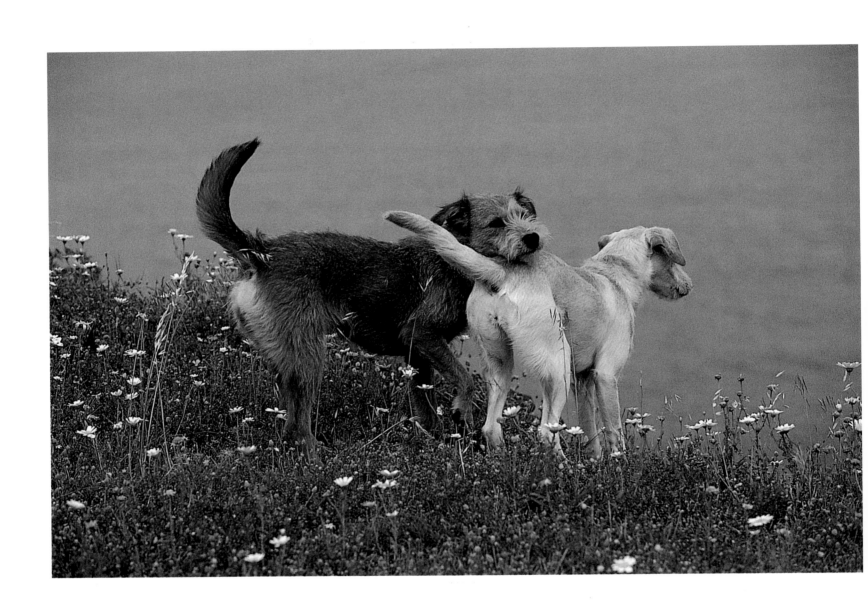

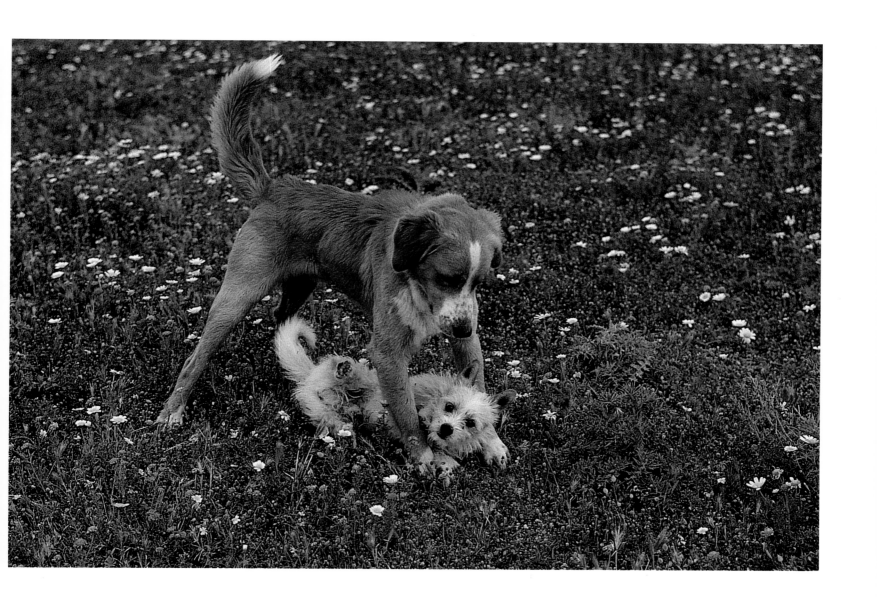

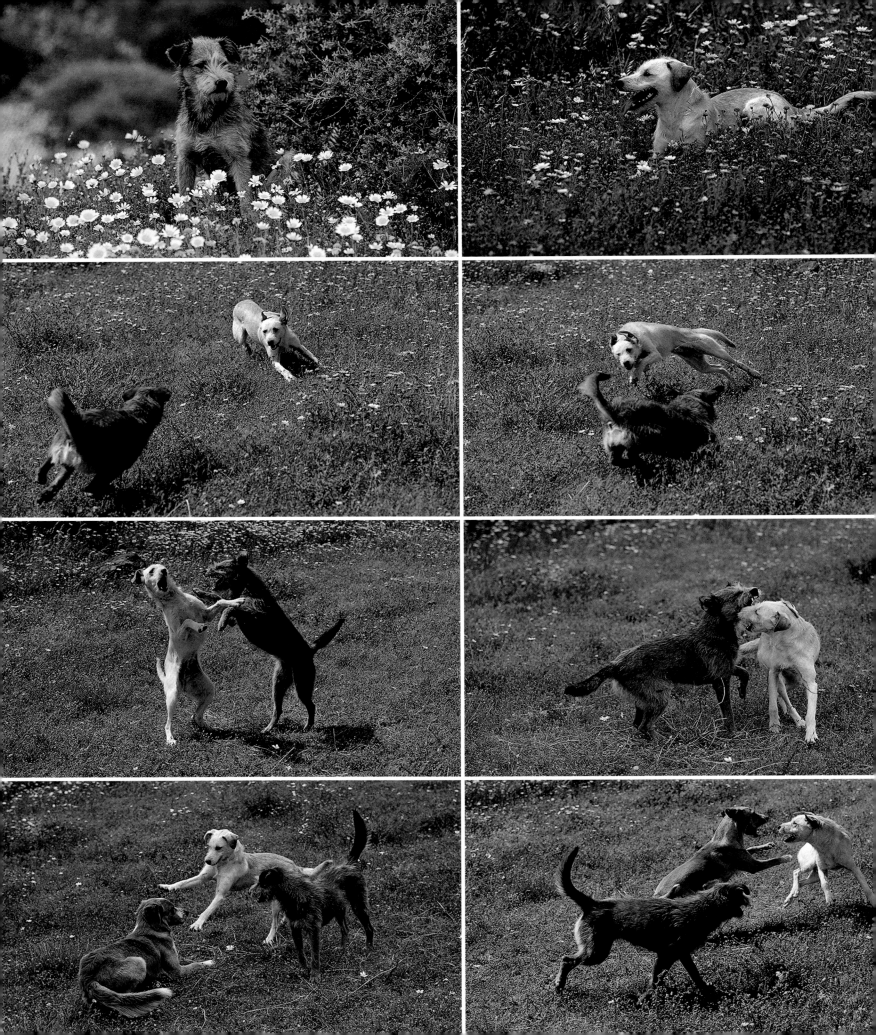

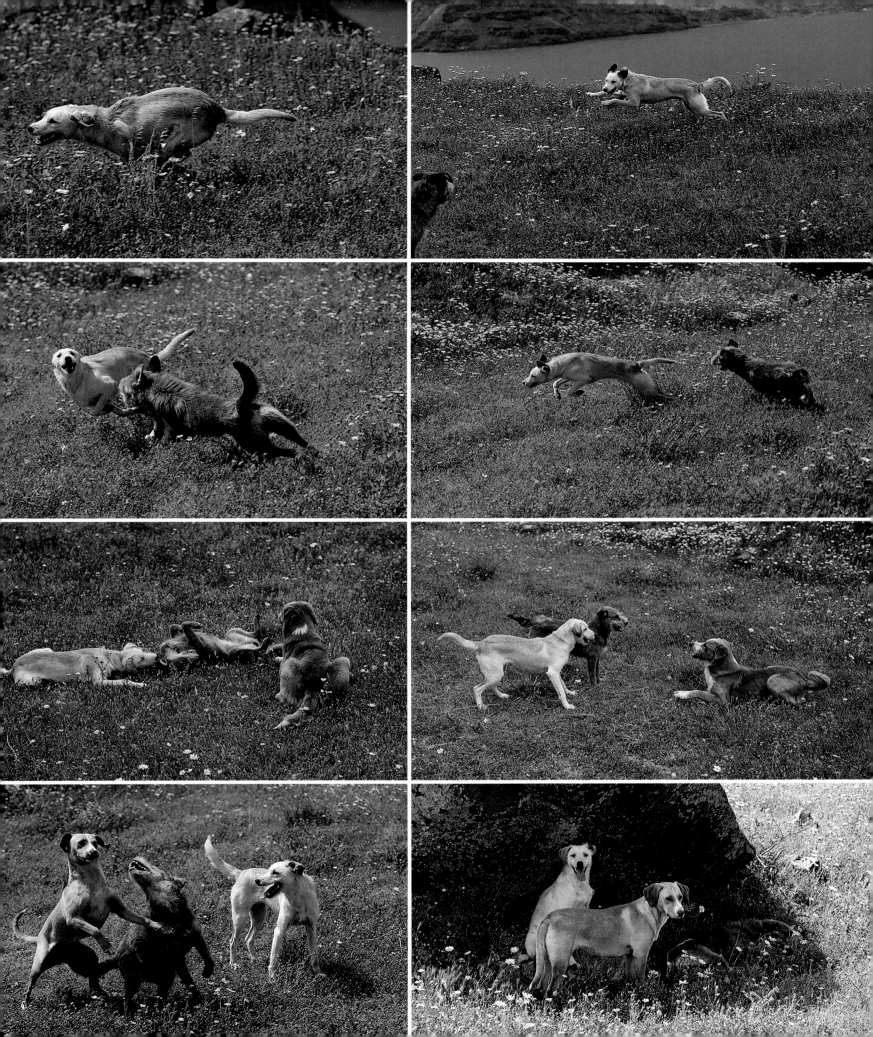

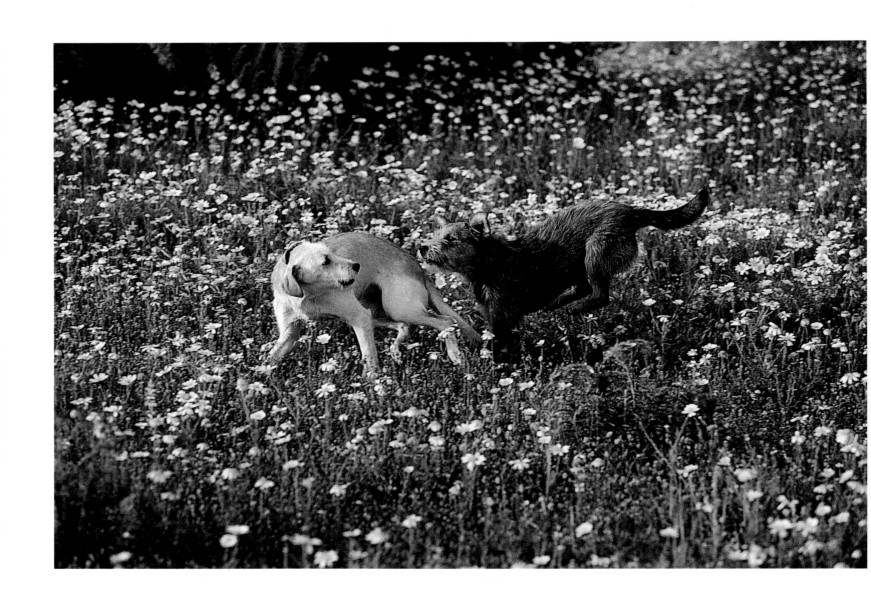

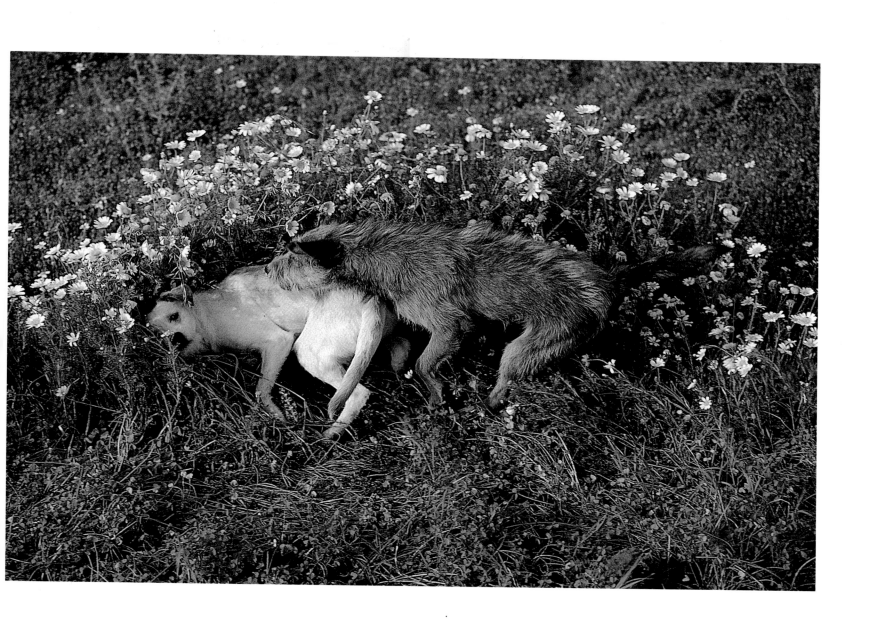

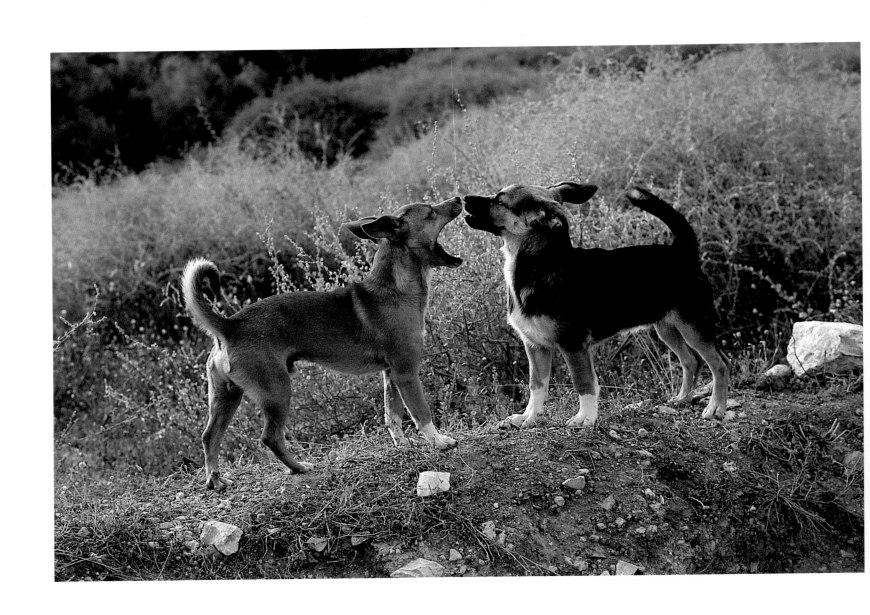

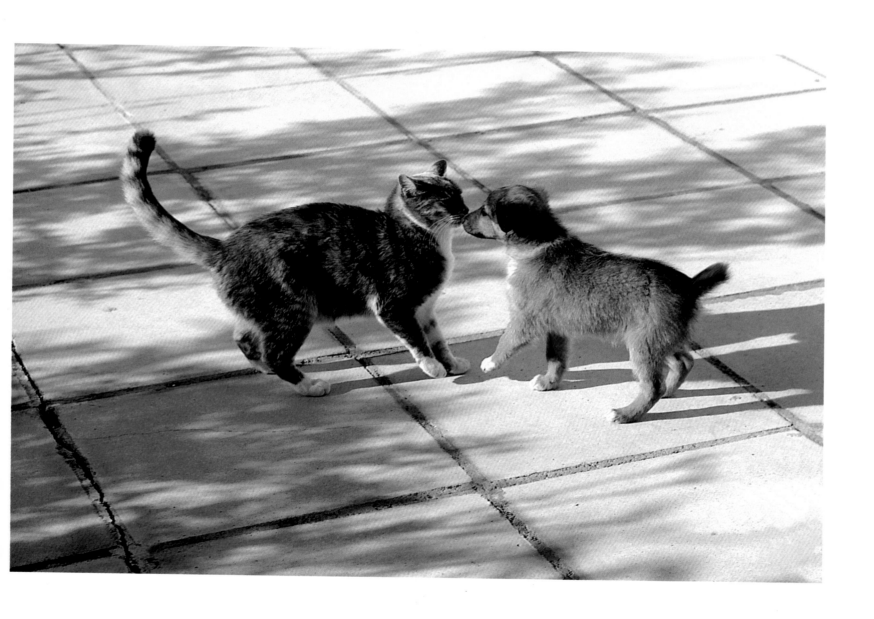

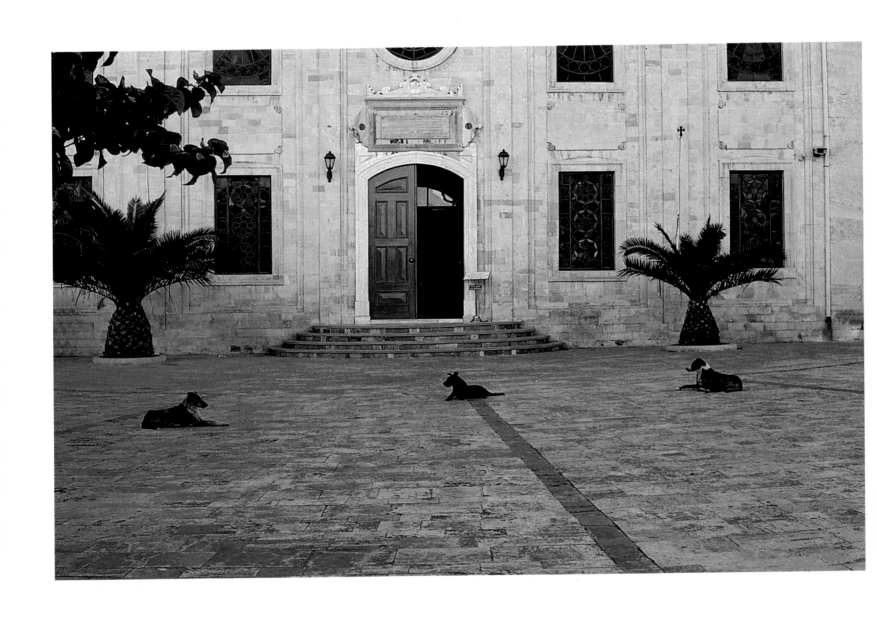

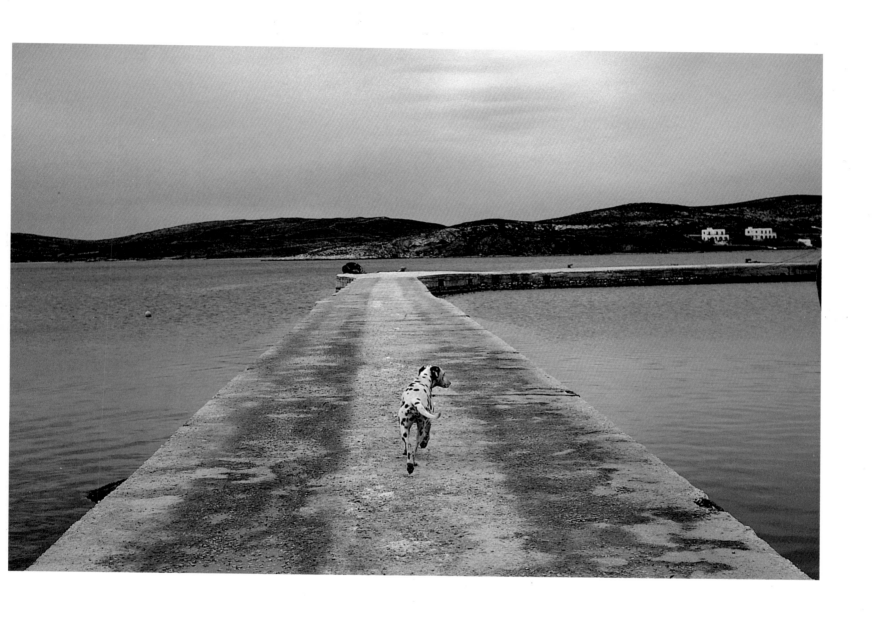

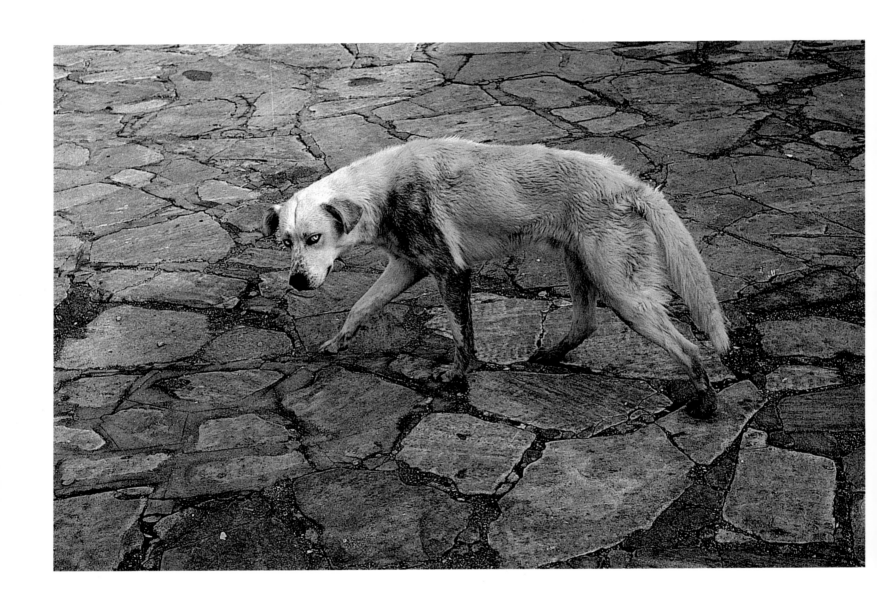

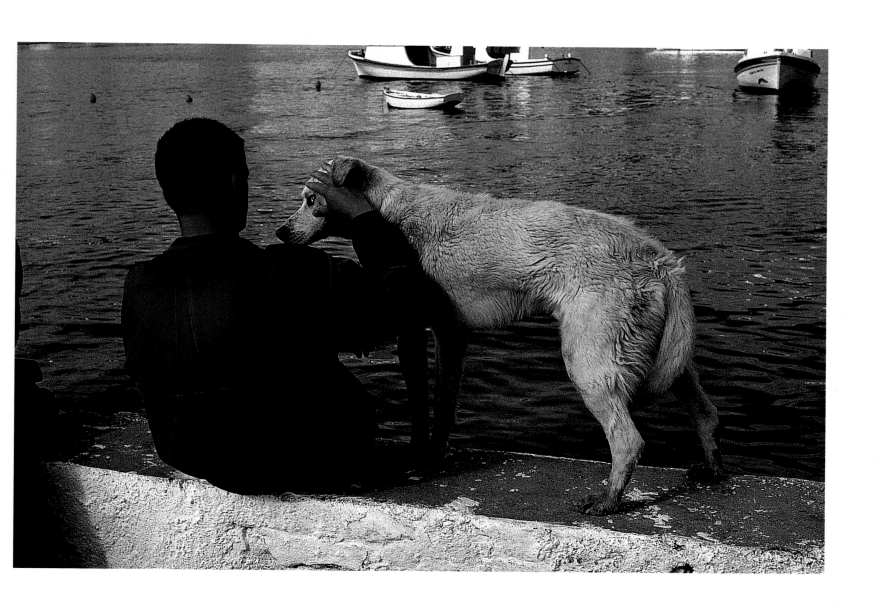

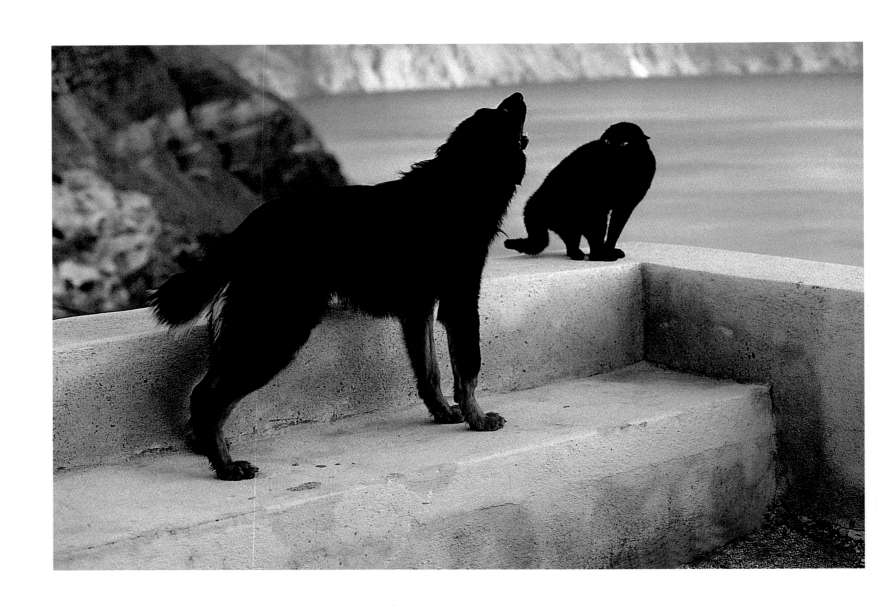

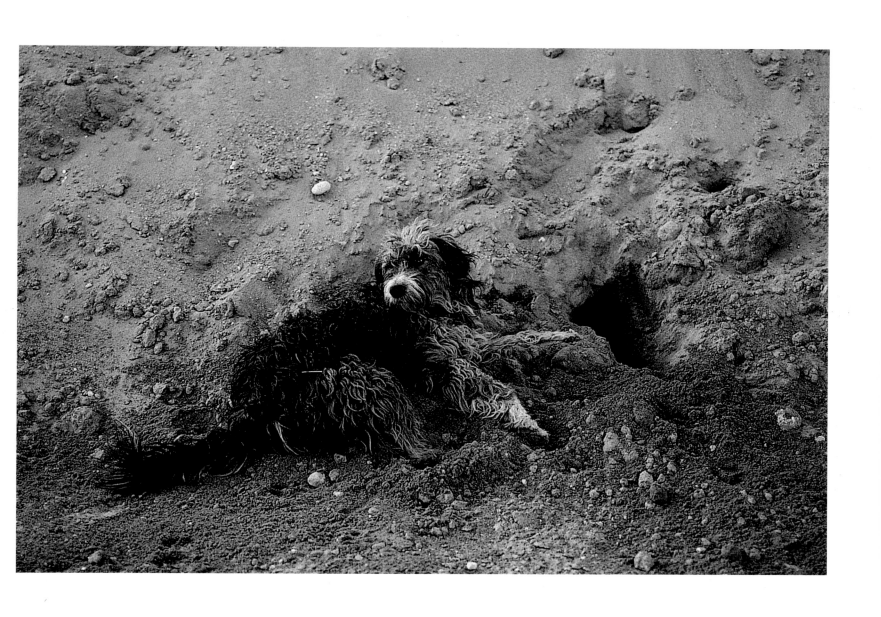

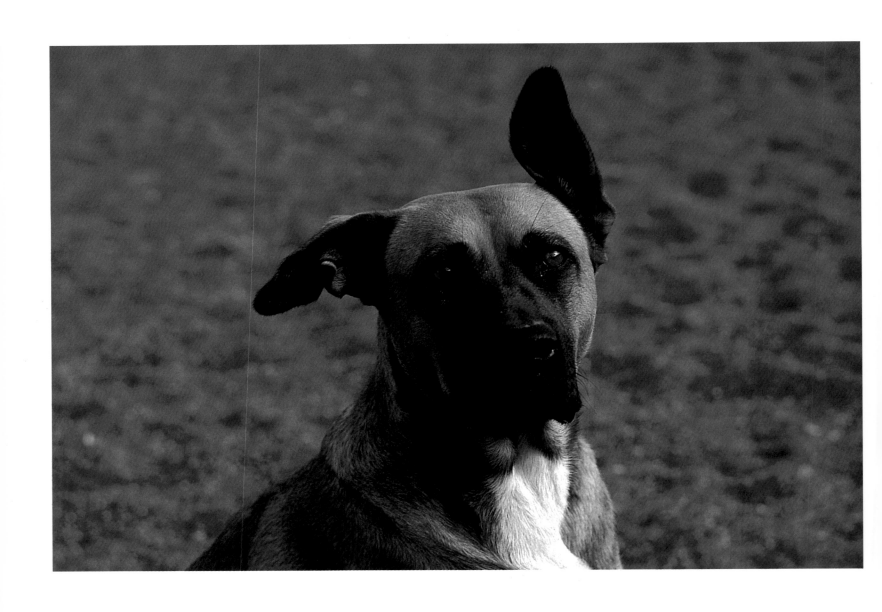

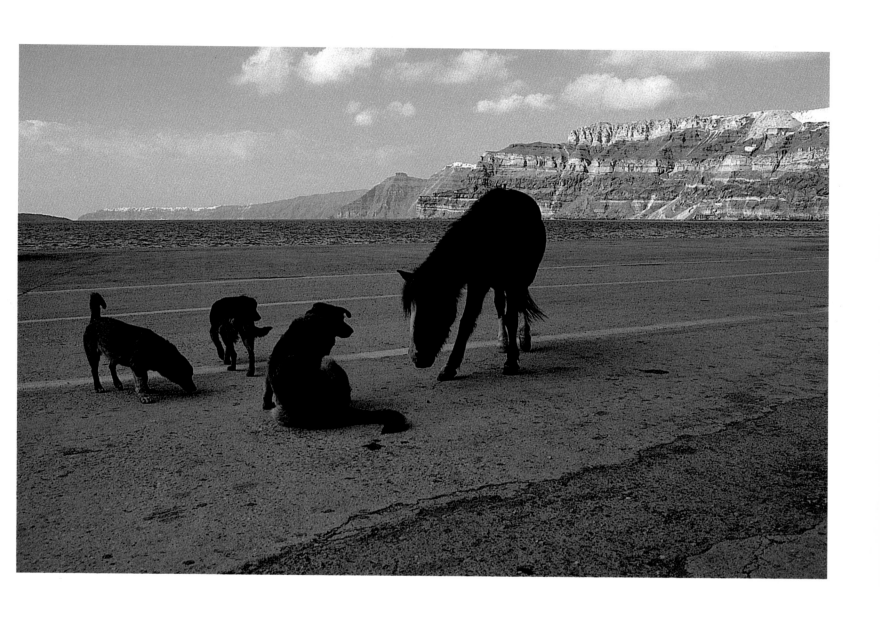

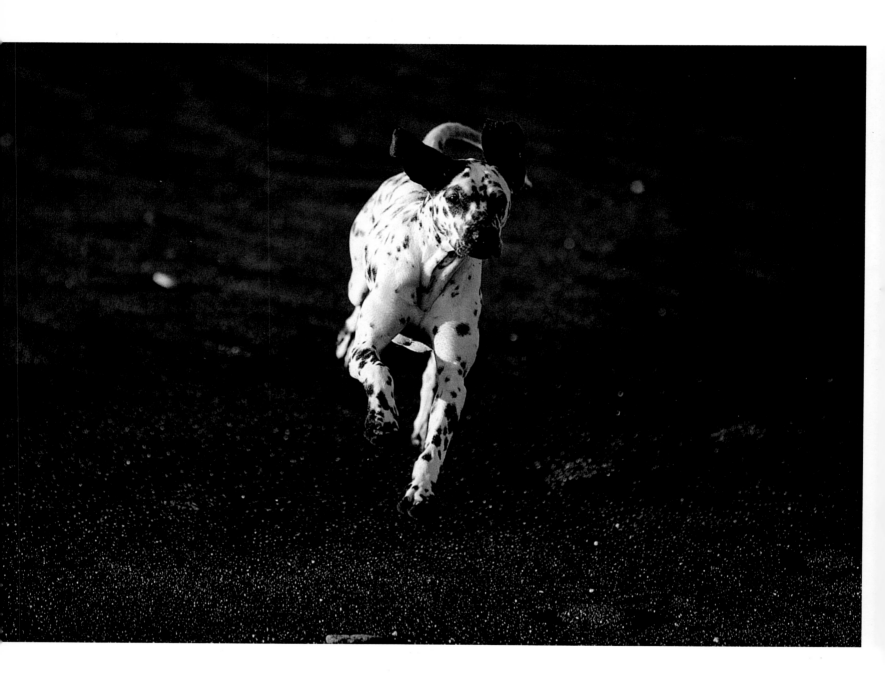

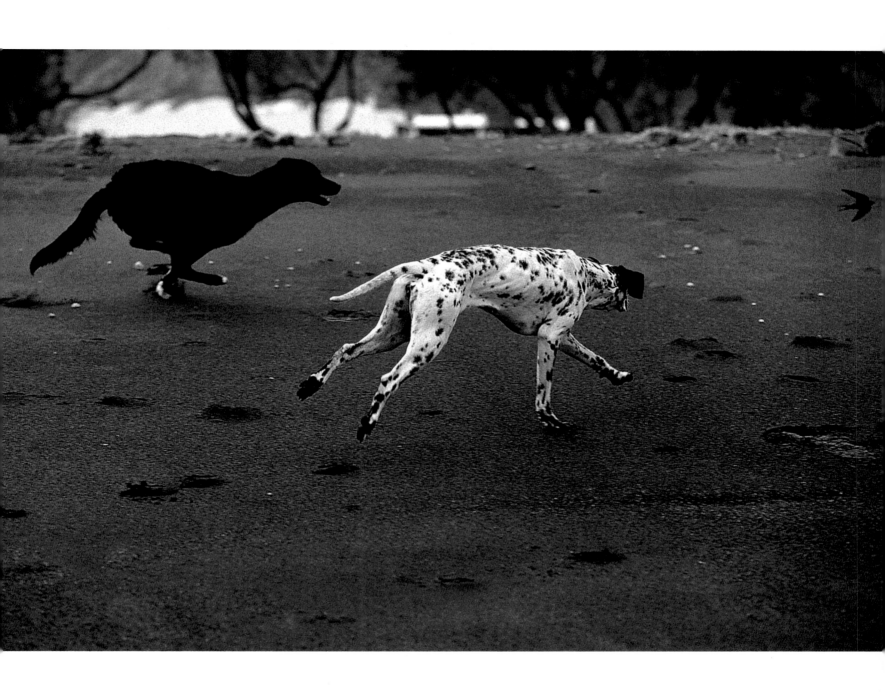

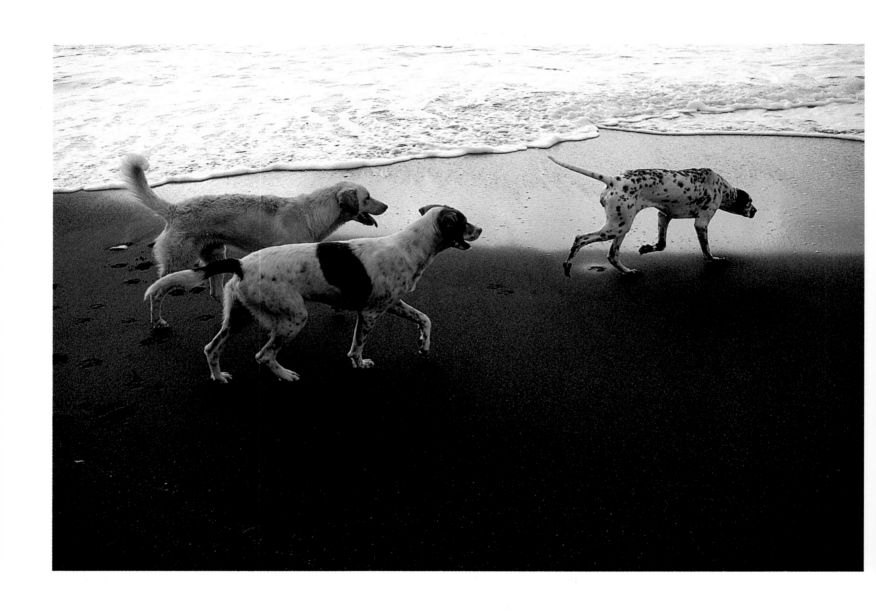

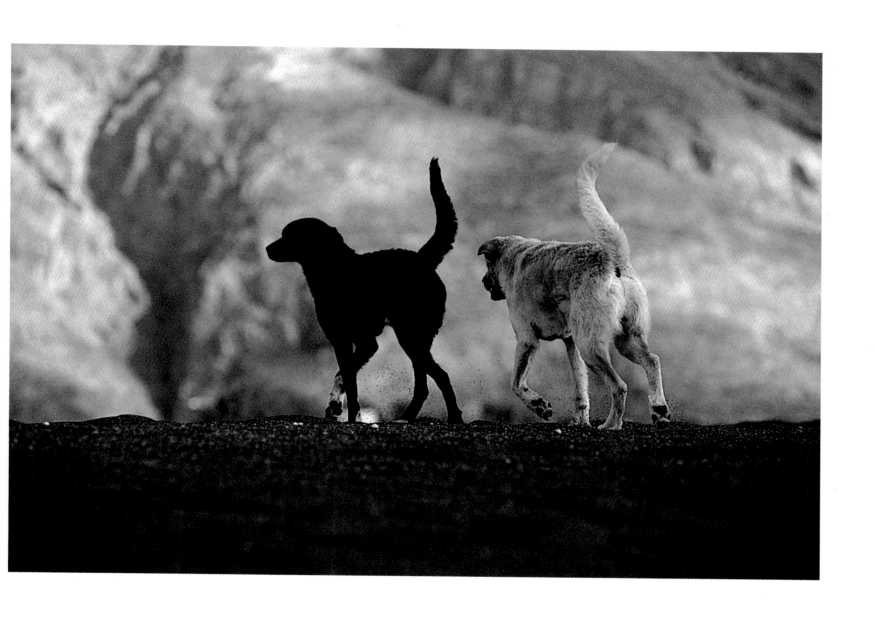

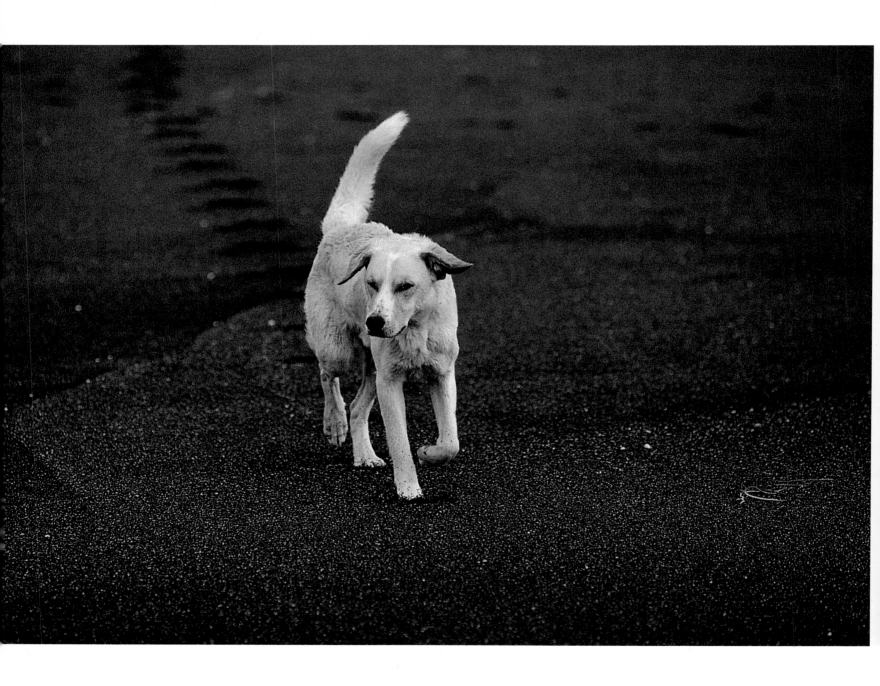

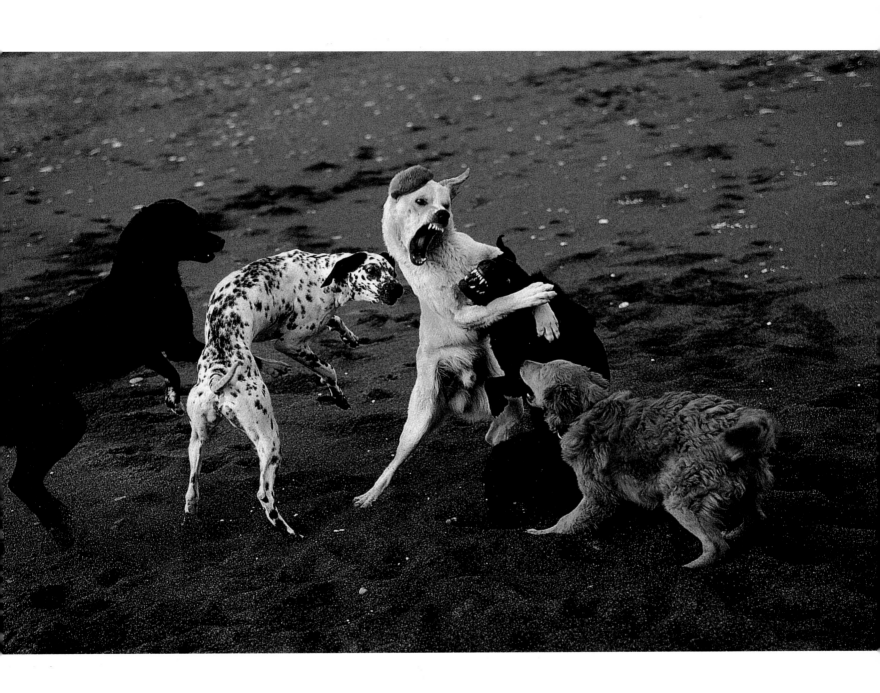

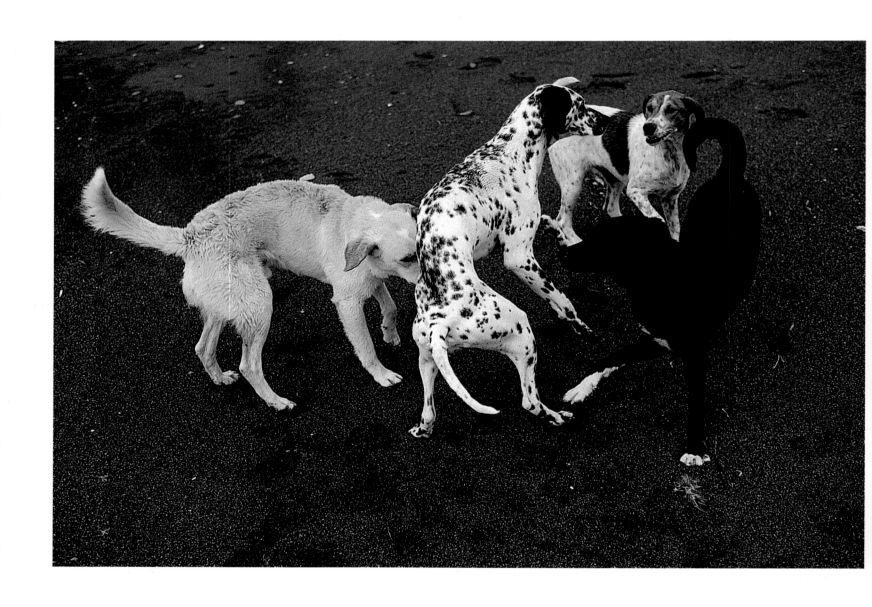

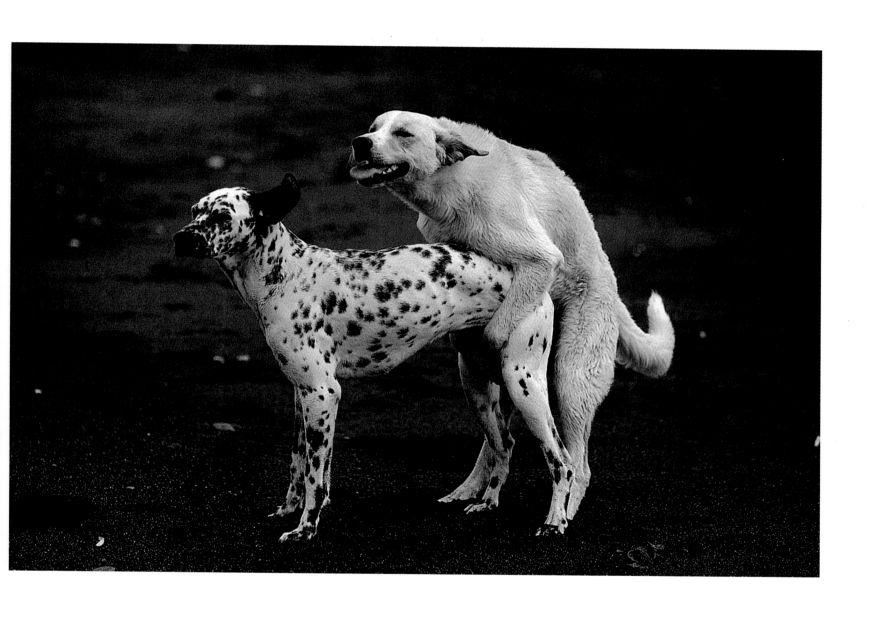